W9-CSA-435

Watercolor for All Seasons

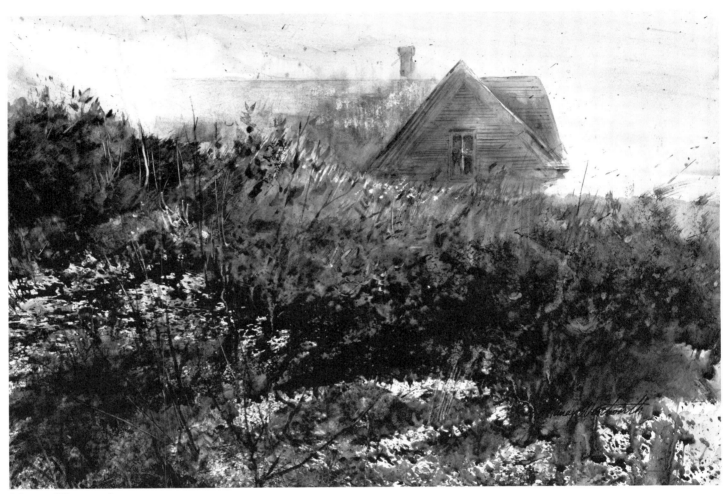

Murray Wentworth
The Ell
12 x 17 inches

Watercolor for All Seasons

Elaine & Murray Wentworth

North Light Publishers

Acknowledgment

We would like to thank Fritz Henning and
William Fletcher, of North Light Publishers,
for their help in putting the pieces together
and for encouraging us to pursue the
writing of this book as a team effort.

Published by North Light, an imprint of Writer's Digest Books,
9933 Alliance Road, Cincinnati, Ohio 45242.

Copyright 1984 by Elaine Wentworth, Murray Wentworth,
all rights reserved.

No part of this publication may be reproduced or used in any
form or by any means—graphic, electronic, or mechanical,
including photocopying, recording, taping, or information
storage and retrieval systems—without written permission of
the publisher.

Manufactured in U.S.A.
First Edition

Library of Congress Cataloging in Publication Data

Wentworth, Elaine, 1924-
Murray, 1927- . II. Title.
 Watercolor for all seasons.

 Includes index.
 1. Watercolor painting—Technique. I. Wentworth.
ND2420.W39 1984 751.42'2 84-25445
ISBN 0-89134-108-0

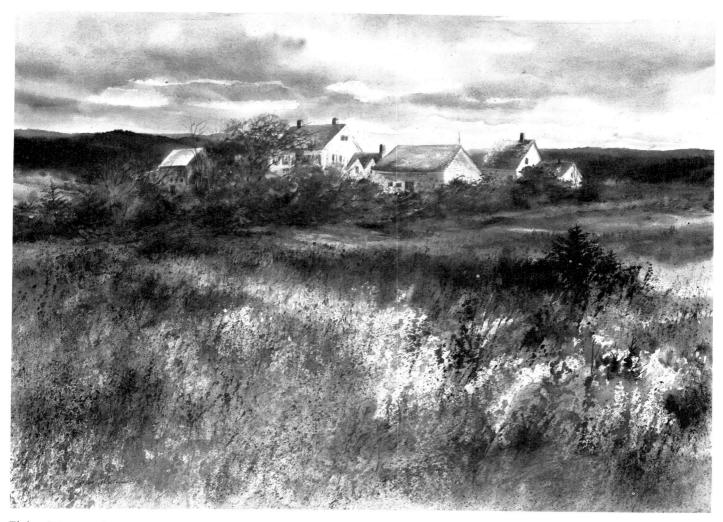

Elaine Wentworth
Passing Shadows
22 x 30 inches

Dedication

This book is dedicated to all of our
enthusiastic students over the years,
including our daughter, Janet, who is
pursuing excellence in the fine arts.

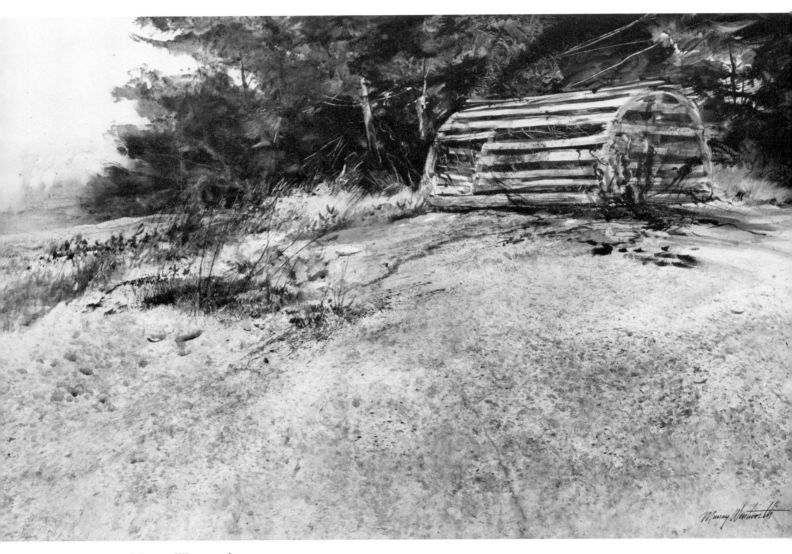

Murray Wentworth
Trap
20 x 30 inches

Contents

Introduction

Watercolor – *from the Caves to the Wentworths*

Creating expressive images in line, shape, color, and texture in watercolor is hardly a recent development. Our cave-dwelling ancestors used watercolor in some of man's earliest visual expressions. Prehistoric methods were simple: the artist scooped up earth and mixed it with water. Even so, his colors were not always "muddy," and his palette included yellows, greens, browns, and reds of many shades. He used scraps of animal skin, feathers, sticks, and his hands for applying the pigment to the walls of his caves. The rock surfaces on which the early artists painted were marked by tones and textures, projections, and indentations. The cave artists may have found some of their images in natural configurations and then embellished them with amazing graphic sensitivity.

We share a common imaginative experience with these ancient artists. Considering this bond, doesn't it seem strange that watercolor as we know it today has developed at such a relatively slow pace in comparison to other mediums used by artists?

Much later, but still two and three thousand years ago, the Egyptians worked with watercolor over which they applied an egg varnish. Another early method was fresco painting, wherein watercolor is applied to fresh plaster, and as the plaster dries, the watercolor fuses with it and becomes remarkably permanent. In medieval times parchment and vellum books were illuminated in opaque watercolor.

About two thousand years ago the Chinese invented paper, but it was not until

Murray hard at work on a student demonstration.

the twelfth century that it was introduced into Europe. By the end of the fourteenth century paper was amply available in Europe, and artists began experimenting with all kinds of mediums. They discovered that ink drawings combined with washes presented a quick, convenient tonal approximation helpful in conceptualizing the light and dark areas of a finished work.

Landscape painting in watercolor, as we think of it today, began in northern Europe. Here the people lived out their lives close to the raw elements of their environment. They came to comprehend and appreciate the ever-changing moods of nature ranging from fierce to gentle. By the fifteenth century artists such as Raphael and Albrecht Dürer were producing sketches in watercolor.

Dürer's perceptive handling of flowers and weeds heralds the beginning of modern botanical observation. His landscapes were complete statements that anticipated the power of watercolor to convey what we call aerial perspective—that is, the changes and nuances of local color caused by the intervening air and atmospheric conditions.

Despite its early use, it wasn't until the eighteenth and nineteenth centuries, in England, that watercolor came into its own as an artist's medium. A number of noted English painters began to go outdoors for direct observation and for impressions of the colors directly from nature.

It is intriguing to contemplate how we are inspired and nurtured by those who went before us, relating to them through an affinity of the senses. John Constable (1776-1837) and Joseph Mallord Turner (1775-1851) were at the apex of the artistic

Murray Wentworth
Preliminary pencil sketch shown at about half size.

achievements of the early outdoor painters. We relate especially to the watercolors of Turner, who is now seen by some art historians as one of the true founders of "modern" art. This is apparent in his later work, which is almost nonobjective in its explosive treatment of color, values, and shapes. Perhaps "nonobjective" is not the proper term for describing paintings of air, earth, and water; they are spatial abstractions combining light, space, and aerial perspective. These luminous, expressive watercolors are full of mysterious suggestions and exploit what we call the "happy accidents"—blots, spills, thumbprints, and drips—which generate unexpected visual effects. Turner was fascinated with atmosphere and light and concentrated on capturing their many facets—smoke, mists, fire, sunsets, and storms.

In America today watercolor is flying to new heights after a slow but steady ascendancy. The American Watercolor Society, founded in 1866, is a major force in the medium's increasing acceptance and popularity. Winslow Homer (1836-1910) is probably one of the strongest sources of inspiration for watercolor painters in the twentieth century. He helped overcome the long-held feeling that workers in watercolor were less than serious artists.

Watercolor has gained enormously in popularity and scope since the end of World War II. The opportunity for instruction through classes, workshops, and books has grown at a phenomenal rate. The American Watercolor Society with its annual traveling exhibitions has expanded during this time and effectively represents artists from all over the United States.

Elaine Wentworth
A 4 x 6 inch sketch

Sources of Inspiration

Planning this book made us reflect on our sources of inspiration and learning. To what extent do we learn from looking at another artist's work? Do we develop a personal vision by seeing on our own, or do we need to be inspired by someone else's vision first? (By "on our own" I mean confronting the source material only; not being guided by instruction or by viewing exhibitions or looking at art books.) We may respond emotionally with feeling for places, objects, atmosphere, and colors, but it is usually after we have seen a mature artist's interpretation that we begin to grasp a vision of the subject for ourselves. Viewing other artists' works is also how we expand our horizon of what interests us.

"I never would have thought of painting that" is a common remark of students. Beginners, especially, are amazed that they never before really "saw" the colors in the familiar sights around them. As Murray reflects, "I wish as a boy I'd had the vision I have now, especially during summers sailing around the Maine islands." It is this *learning to see* that is so crucial, and in this area we all need as much help as we can get.

When Murray began art school, he was exposed to the work of John Singer Sargent and Winslow Homer at the Boston Museum and to Andrew Wyeth through his teacher and later his painting companion, MacIvor Reddie. Murray's enthusiasm for the work of these artists spearheaded his personal growth.

Late Sunday afternoons, after painting on the salt marsh with MacIvor, we would sit around and talk about painting. Mac had a file on Wyeth that contained little black-and-white reproductions clipped from magazines and exhibition catalogs. Wyeth's approach was the source of much

discussion, but it was Sargent's warm palette and color harmonies that most influenced us. Other influences were two Swedish painters that Mac introduced us to through magazine pictures—Anders Zorn and Bruno Liljefors, both of whom painted with the broad brush strokes that Sargent used with such vitality. In time Murray's high-color palette became subdued, and the characteristics of his brushwork changed as he developed his ability to handle the smooth surfaces. Later the color range returned but in more subtle combinations.

As for me, when I lived in southeastern Alaska during World War II, I was touched by the beauty of the fog-shrouded mountains and fjords, and I attempted watercolor impressions on location whenever I could find time—and it wasn't raining. It was frustrating, for I not only lacked training but had no one else's work to look at for inspiration. I had loved the watercolors of Sargent, Dodge MacKnight, and Homer in the Boston Museum when I studied figure drawing there, but my memory of them was vague and I was too untrained for the experience to be of much practical use. All I can say for those early watercolors done in Alaska is that I had some intuitive sense for color.

When I returned to Boston after the war, I became a full-time art student. Neither Murray nor I studied watercolor in art school because it wasn't offered. Without splendid examples to study independently, our growth in this area would have been stunted.

It is important to keep an attitude of continuous study in order to progress. In recent years we found new inspirations and channels of thought through Carl Sublett, a fine painter-teacher. In painting sessions with him on the coast of Maine and discussions about work in a relaxed yet intensely inquiring atmosphere, we were introduced to a broader vision that ranged from realism to abstractionism. We became aware of new ways of solving old problems and began to experience color and design more subjectively. Instead of being dependent on the visual truth of nature, we became more attuned to using the source material as an initial "given" shape from which to create new forms. All this deepened our imaginative and intuitive experiences in painting.

We recently encountered one of our early inspirations at the new wing of the Portland (Maine) Museum of Arts. On exhibit was the Payson collection of Homer's work, including a few watercolors we had never seen before. Sometimes we outgrow more than assimilate certain influences, but in the case of Homer, we discovered his work remains influential.

Homer's vibrant watercolors, which come across without benefit of perfection of technique, have the power to enthrall. His strong value pattern and direct approach go beyond technique. We could say that his work leads us across the spectrum of abstract design to a realistic representation of the subject.

Many students stop short in their studies with the acquisition of certain technical facility. From then on they repeat themselves instead of growing as artists. Ralph Waldo Emerson put it nicely when he wrote: "Nothing astonishes men so much as common sense and plain dealing. All great actions have been simple, and great pictures are."

Our goal in this book is to suggest the simple, basic things we have learned over the years that make up the sensory perceptions we use in painting watercolors. We hope what we have learned will help you learn, so you can be a better, more understanding artist in your own way.

Murray Wentworth

Elaine Wentworth

Studio and Materials

People always seem to be interested in seeing a studio that two people use jointly. They probably wonder how we manage to work together and remain happily married. In actuality, there are two distinct and separate working areas in one large room. Even though we work almost side by side, each of us is an island unto himself during the time he is absorbed in his work. Each struggles alone within a private world, interpreting his own view. Working together requires respect for the other's needs, but our involvement in our work creates a kind of personal isolation that seems essential for the creative process.

The studio consists of the entire upstairs of our house. The walls and ceilings are painted white to assure as much light as possible. There are three north windows in a row which bring in a fair amount of natural light next to the working tables. On one side of the room is a stock rack for watercolor papers, boards, and mats. We store framed paintings along the stairwell walls and wherever else we can find room. Two storage bins hold unframed work, as do large folders for recent work and finished pieces. Under the eaves are additional storage spaces. In a corner is a utility sink.

More than half the room is used for working. It is divided by a small sitting area with a couch and table. Nearby is a display easel for viewing work. A bookshelf separates a small office space for desk and files. One corner is devoted to music. Murray has a set of drums and a stereo system, which allows him to practice with his favorite jazz artists.

Work Surfaces and Painting Equipment

There are many new and elaborate drawing tables on the market, but for indoor work we still prefer the basic large tilt-top drafting board set on pedestal legs. Its flexibility allows working at any angle. It can be raised or lowered so you can work either standing or sitting.

Along with natural north light, we use a photo flood lamp with a 250-watt blue bulb on the left side of each drawing board. By pointing the lamps toward the ceiling the light bounces back supplying a diffused but bright light. In addition, we have several rows of fluorescent lights, a close substitute for daylight.

Next to each drawing board is a large taboret on rollers which serves lots of needs. It has sliding doors and three drawers for storing small items. These useful pieces of furniture were custom made for our individual needs and working habits.

For indoor use we both prefer a large plastic palette with deep wells for holding paint and plenty of room to mix washes. We find the Pike palette both suitable and long-lasting. In addition, we use heavy white porcelain butcher trays for mixing washes. Actually, almost any white surface such as a large table plate will serve as a satisfactory palette.

On location we prefer an enameled aluminum or metal folding palette that can be held or put down flat on the ground. With a thumb hole and large mixing area this type is most convenient.

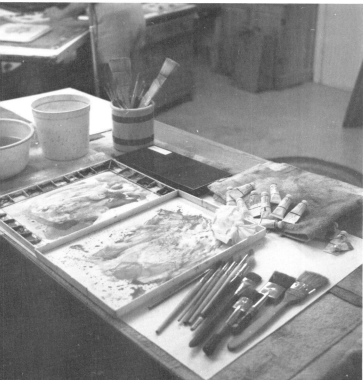
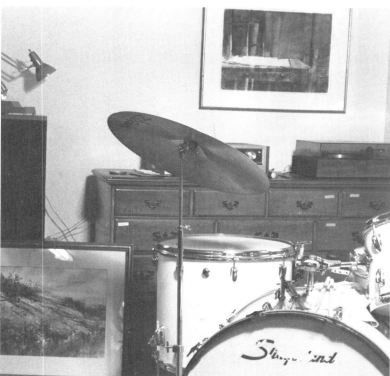

Our studio layout complete with Murray's drums.

Additional Tools

Other important tools are the scraping blades and sponges. Synthetic sponges can be cut into variously shaped wedges, and natural sponges can be squeezed to make fine marks or lift-outs. We both use various blades for scraping out lights and removing paint from the surfaces. A discarded credit card works well as a scraper, either as is or cut into several pieces. Brush handles that have a chiseled end for scraping paint are also useful for scrubbing a textural grain and for lightening.

Paper

It pays to experiment with various papers and get familiar with their individual characteristics; 100 percent rag is essential.

The *smooth* (hot-pressed) papers have a hard finish that allows the paint to "ride" the surface, producing some crisp, hard edges and interesting paint textures. On such toothless paper, reworking and changes can be made easily. To a large extent, it is better to create your own textures than to rely on the texture of the paper. Hot-press allows virtually any type of painting from loose to tight, and it will stand lots of abuse. This surface requires some experimenting, as it may produce a "tricky" appearance in your work.

Cold-pressed, or *medium*, surface has a closer texture than rough and is great for varieties of brushwork. It will also take rough punishment. This is a fine surface to use for drybrushing.

The *rough* surface is quite rugged in texture, full of hills and valleys, which help to produce sparkling textural effects.

Generally, we find smooth and medium surfaces the best for our work. The boards we both use are Arches cold-pressed, Fabriano, and the 3-, 4-, and 5-ply sheets of Strathmore paper, including the heavyweight smooth, or *high-surface,* illustration board.

Blocks and pads are available in various sizes. We like the medium cold-pressed Arches and Fabriano best of all.

Colors

In choosing paint and paper we recommend buying the best. We both use the artist's grade pigments for their excellent handling qualities and permanence. Through experimenting you'll find the various water-to-pigment ratios needed in mixing the different colors. Some are very transparent; some quite opaque.

There are many different tube and pan colors available to the watercolorist. Many are nonessential, as they are close variations of the standard hues. You don't need them all. You can narrow your choices to the ones that work best for you. Instead of a great assortment of greens, for example, you can mix a great variety with new gamboge and Winsor blue. Thalo blue works if you want intense greens.

We use Winsor & Newton No. 5 tubes in most all the colors. Some, such as cadmium red, will last a long time, so you need not buy the large tubes. Over the years we have tended to simplify our palettes down to earth colors—basically, warm and cool versions of reds, yellows, and blues. For example, ultramarine blue is relatively warm, slightly to the red violet side on the

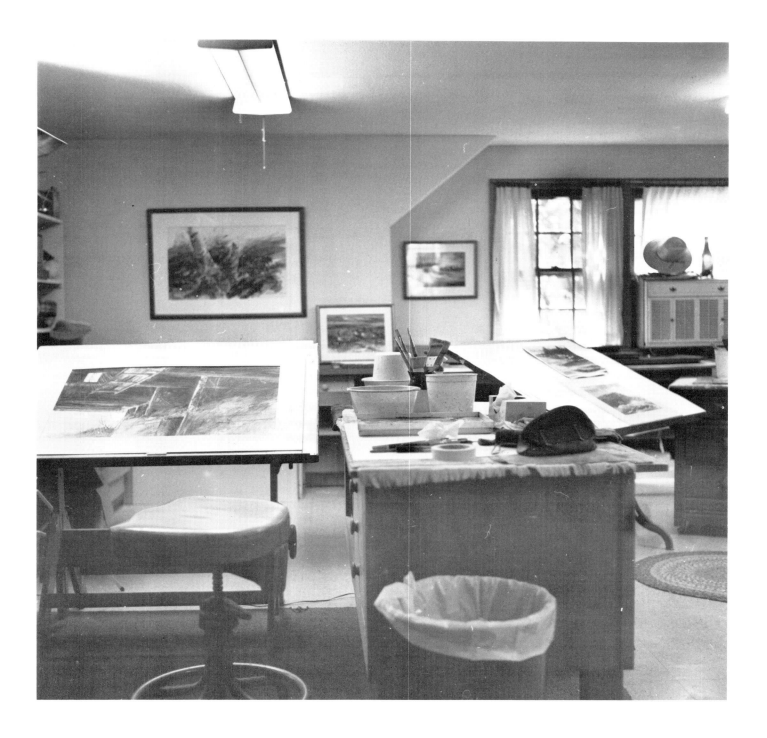

color wheel, whereas Winsor blue and thalo blue are cooler, veering to the green side.

Beautiful neutrals or grays can be made from ultramarine blue by adding burnt sienna or burnt umber. These offer a luminous quality that vary in value according to the amount of water added. Mixing Winsor blue and burnt umber gives a very rich, dark tone. The use of black is optional. Mixing color with either ivory or lamp black can lead to muddy washes. Occasionally, I will dip into a black to soften the intensity of the strong Winsor blue, and ivory or lamp black added to brown madder alizarin will give a nice brown mixture. But be careful with black—use it sparingly.

Our palette consists of:
 brown madder alizarin
 cadmium red
 new gamboge yellow
 raw sienna
 yellow ochre
 burnt sienna
 raw umber
 burnt umber
 ultramarine blue
 Winsor blue
 cobalt blue
 cerulean blue
 ivory or lamp black
Additional colors for limited use:
 Davy's gray (chalky yellow gray)
 olive green (very thin)
 Vandyke brown (cooler than burnt
 umber)
 manganese blue (opaque and brilliant)
 alizarin crimson (transparent but
 powerful; good in mixtures)
 cadmium orange (opaque, long-lasting).

Brushes

Elaine and I use a similar selection of brushes which serve different functions. Because I am hard on brushes, I avoid using the most expensive red sables, although they have always been a favorite.

We use both the natural hair and the synthetic fiber brushes. Sizes vary from No. 4, 5, and 8, 10, and 12 in the rounds for most of the general painting. A No. 14 is useful for larger washes. The white synthetics are also suitable, but they do not hold as much of a load as do the natural hairs.

For large broad areas we use 1- to 1½-inch flat bristles. The Grumbacher bristle/oxhair brush is a favorite in 1- and 1½-inch widths. The hardware store oxhair house-painting brush also works well in 1- to 2-inch widths.

The Hake brush is useful for delicate applications of paint and for glazing. It has very soft, sheer, white hair and is available in various widths.

A 1-inch Aquarelle with a plastic beveled handle is useful, as the tapered end can be used for removing and scraping paint from the paper surface.

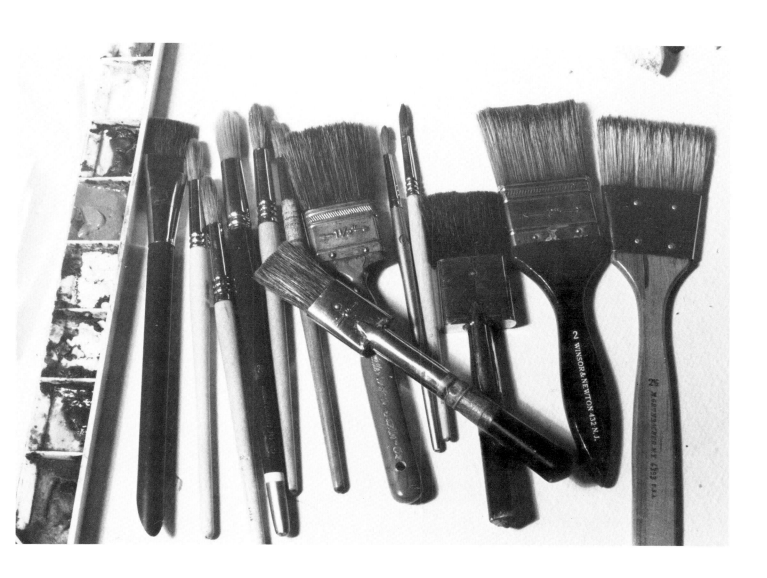

Outdoor Equipment

The matter of outdoor equipment comes down to how much you want to carry. It is not necessary to overload yourself with gear. If you drive to location, you can carry all kinds of equipment, but when walking and toting your kit through a field or across a ragged shoreline, you learn to limit yourself. Over the years we have narrowed down our outdoor equipment to the essentials.

You can sit on the ground and lean the board against a tree or rock; or set up an easel and stand or sit, whatever suits your mood or picture requirements. Let the subject and your composition dictate where and how you work; don't set yourself in the comfortable shade if it will be a disadvantage to your picture. Students sometimes settle in snugly in a cozy location and then see nothing they want to paint! The fact is you sometimes get your best painting results when the conditions are the worst from the comfort point of view.

For many years we've used the wooden Anco watercolor easel, a versatile type with telescoping legs that adjust for rough terrain. It tilts to any angle for working and

is light to carry. Just recently we began using the French easel and have found it to be a portable outdoor studio, as it has a drawer and plenty of room within the box area for supplies. It will not tip over or be affected by gusts of wind. It can be used at any angle or even flat on the ground with the legs folded. The folding black palette fits perfectly across the drawer, leaving one hand free from holding it. The easel will also hold a drawing board.

You may wish to carry a bag for sketch pads or other extras. Both Murray and I use a canvas painting bag for extra water, sketch pads, and paints. It is easily carried over the shoulder, leaving your hands free for the easel and other gear. I also like a lightweight stool with canvas pockets on each side.

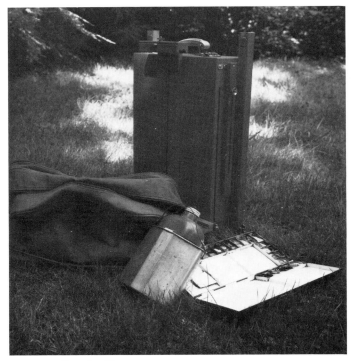

Our sketching gear.

The art of pictorial creation is indeed so complicated—it is so astronomical in its possibilities of relation and combination—that it would require an act of super-human concentration to explain the final realization. Such an awareness is usually absent in the artist. He will never be able to explain the full process which led to his creations.
—Hans Hoffman

Inspiration

Inspiration to paint a picture can happen at any time. It is a matter of getting yourself into the proper state of mind. A walk in the woods or along the shore usually sets the stage for me. There are no set schedules or schemes for finding good ideas; they just happen. No doubt years of searching helps.

I often have so many ideas it's hard to sift through them and settle down on one theme. Looking at a sketch done ages ago can trigger an idea for development. At times I'll be working on a watercolor, trying intensely to hammer out a good painting, and I'll see something else completely unrelated to what I'm doing. If I go after the new approach, it usually proves rewarding. The quick response often brings the most satisfying results.

Painting is largely a matter of impulse. It should be an exciting, aesthetic emotional experience. Look for the *unexpected* in the scene. Avoid set formulas. Search for a new approach, one you haven't tried before. Don't be content with the immediate, obvious picture solution.

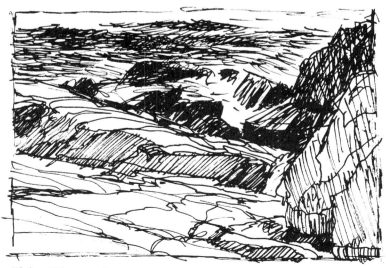

Elaine Wentworth *A preliminary compositional pen sketch*

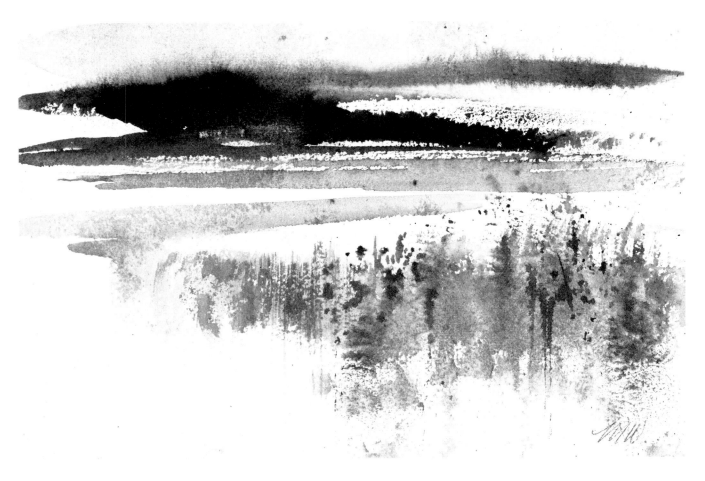

My Approach / *Murray Wentworth*

A strong abstract pattern of lights and darks is essential if a painting is to be effective. Without this element of design the work just falls apart, no matter how much detail, subject matter, or expert rendering is evident. Good pictures must be based on good design.

I like to think my work reflects a balance between the real and the abstract. My paintings are considered by most to be representational. That term is more palatable for me than *traditional.* Over the years I feel I've learned to "see" in a more abstract manner. Along the way I have come to admire the works of Franz Kline and other Abstract Expressionists. Frankly, the word *traditional* gives me a sense of being locked into a prescribed approach with a predictable result. That is not the role I see for myself.

Historically, artists have dealt with the problem of creating on a flat surface the illusion of three-dimensional space. In modern art, objects in space, or space itself, may become distorted, pulled out of natural shape, and compressed or expanded for the sake of the design. Realism is not a factor. As a result, the subject, the content of the painting, is reduced in importance and becomes more identified with the physical surface.

Whatever the subject, I try to stress a sense of excitement and power in my interpretation of the scene. Invariably, the picture idea is triggered by something seen in nature. The painting *Sudden Light* (page 158) is an example of what I mean. I began it on location and carried it to near completion, then brought it back to the studio and studied it for several days. After a

lot of work it still didn't seem right. The rock mass needed pulling together. The final solution became obvious in a strange way. In the studio a curtain cast a diagonal shadow across the easel and a portion of the painting. That was all it needed! The darker value of the shadow gave form and emphasis that the frontal plane needed.

Most of the time I'll approach a subject with little or no preliminary sketching. Of

course, the amount of drawing on the paper depends on the complexity of the subject matter. Structural themes usually require more time than a large broad landscape, where drawing with the brush is essential. I try to minimize pencil work to allow freedom for building brushwork as it progresses; occasionally, I'll use a charcoal pencil for various details.

Generally, I stay with one idea during a day's painting. Recently, however, I've found that bringing along several sheets of paper gives me the chance to start two or three paintings in a single day. It can be exhausting but quite rewarding.

After deciding on a composition, consider making pencil studies and planning the drawing of a total composition on the finished piece of paper. Study this overnight. Then *go back* on location to begin the painting while the images are fresh. This has proved worthwhile for me, especially for a

complicated design requiring much drawing. Such an approach gives you a chance to think ahead and to better visualize the finished results.

Before losing my initial interest in a subject, I often repaint a watercolor that has failed. This is one way to improve the work and solve the trouble you had originally. Many times it is exciting to work out several paintings based on a single idea. *River Ice* on pages 48 and 49 shows what I mean about visual variations on a single theme.

Approaches vary with each painting. Most of my earlier work was done entirely on location, whereas my later work is usually a combination of both location and studio. I am a firm believer that close contact with nature is essential to generate fresh ideas and gain new insights. Studio work alone can lead to contrived or mannered paintings.

Techniques

Many students and professional artists alike are dazzled by slick technique and the tricks of watercolor. Sparkling technique can be impressive at first glance, but when viewing and studying the works of Homer, Sargent, Turner, and Wyeth, we are concerned with *what* they have done rather than *how* they did it. Techniques are hidden behind good painting. As beginning art students we all must acquire the technical skills of any medium and develop control over our materials. At this period we are pleased if we can accurately represent a subject with reasonable technical skill. My first approach was rather restricted, using the same textured paper surface for all my watercolors. Later on I had the courage to try a smooth surface while I watched with great dismay as the washes ran out of control! Seeing my first big Wyeth show at MIT (about 1960) inspired the use of smooth surfaces. I began to paint in and out of control and freed myself from the obvious and safe route.

Using a trial mat: The use of a trial, or "working," mat is essential, as you cannot judge a painting taped to a board all covered with spatter. Mats may be cut to fit whatever size paper you like to work with, or you can use mat strips. When the watercolor is brought back to the studio, place it under a mat to study the results. Working on the painting while it's in a mat is a good idea, too.

Using a camera: I usually take photos of subjects that can be used for future paintings such as snow patches and various shapes of rocks, trees or the like. Photos depict fact and should only be used for that purpose. The camera is a helpful tool, but is a poor substitute for our own vision and personal reaction to a subject.

These photos show the various techniques that work well in creating textures in watercolor.

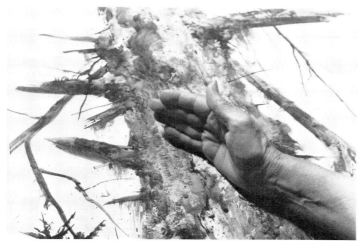

Pressing and rolling the side of the hand into the surface to create texture

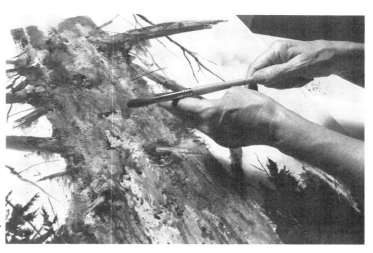

Tapping the brush against the hand or another brush to spatter paint in various directions for surface textures

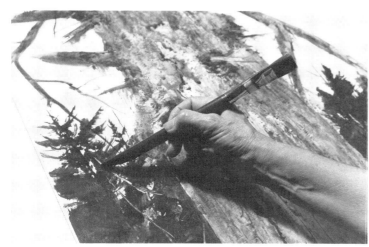

Using the back of a beveled brush to scrape out highlights

. . . the beauty of this art mainly consists in things that the language is not able to explain.
— *Eugène Delacroix*

Getting Started / *Elaine Wentworth*

After the initial idea for a painting takes hold, it's time to seize the essentials and nail them down. This kind of thinking should be done visually with pencil, pen, or brush flowing across the defined borders of the pictorial space. Call them doodles, gestures, sketches, roughs, studies, or what you will, but *do them.* And be sure to define the outside dimensions of these thumbnail drawings.

Some artists say the best you can do in attempting to teach composition is to caution the student about what not to do. Such an approach bothers me. Who wants to clutter his or her mind with a list of negatives? However, it may help to raise your awareness by taking notice of someone else's evolution from inspiration through the picturemaking process. It is a difficult procedure to document, as much of the mind's function is beyond grasp of comprehension.

As artists we must explore two realities: the one around us and the one within us. Artistic intelligence must balance inspired feeling with reason and control, and it is this combination that we hope to share with you as we paint our way through the span of seasons. It is reported that Piet Mondrian spent many years deeply involved with

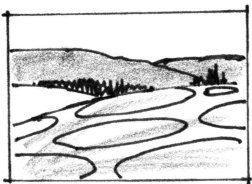

Figure 1. This simple diagram shows some of the basic shapes and lines immediately apparent in an unspectacular group of trees seen along a roadside. The tree trunks establish a rhythm by their forms, but varied spacing. This movement is balanced by the carved diagonals in the foreground, and the darker mass of the background is stabilized and made more interesting by the contrasting foreground.

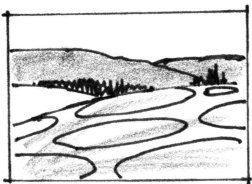

Figure 2. *Here the perception of space is deeper. The landforms are basically convex, and the planes overlap and vary in size. The center of interest becomes the small dark tree area in the middistance.*

Figure 3. *Notice how the positive-negative shapes establish a kind of rhythm. None of the shapes are of the same size, but each is similar in configuration. Again, the small dark mass suggesting trees in the midforeground becomes the interest center.*

nature, analyzing the structure of forms. Ultimately, he needed no natural object to inspire his highly organized compositions to create pleasing harmonies. Sometimes I am moved by the significance of an object; but more often inspiration springs from the light and atmosphere in nature.

An approach used by some artists is to become involved with the materials and "find" the images as they watch what develops from accidental configurations. The "found" forms inspire you to continue to bring them to some stage of coherence, whether abstract or realistic. Whichever way you go about it, you have to come to grips with some of the principles of pleasing spatial relationships in order to develop any theme effectively.

Ultimately, the design and composition of a picture rest on a visual balance of elements that harmonize variety within unity. These conditions are fundamental, and the artist, no matter what his goal, must meet them satisfactorily. The principles are basic and relate directly to our environment. They evolve from our association with the earth, the sky, the horizon, gravity, light, air, movement, and the growth of all things.

Figure 5. *Here is a sketch suggesting shallow space emphasizing a frontal picture plane. The light area is balanced both horizontally and vertically by the contrasting dark shapes. The flow-through linear pattern and middle value create variety and rhythm.*

Figure 6. *In this sketch the darker values are dominant, and balance is maintained by the smaller light areas of varying size and shape. The small darks at the right and across the lower center become the center of interest.*

Figure 4. *These are simpler shapes and there is less movement apparent than in Figure 3, but variety, balance, and rhythm are maintained.*

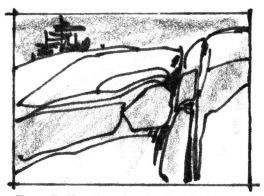

Figure 7. *Here is a sketch where balance, rhythm, and variety are established with lights and midvalues. The area of interest is created by the pattern of similar shapes running across the center, accented with a few darks.*

Preliminary Studies / *Elaine Wentworth*

Preliminary studies help you identify what most attracts you—identify it visually, not verbally. Occasionally, students will tell me at length what they plan to do while showing me a few random marks on their sketch pads. "Don't tell me about it; show me." It is difficult for us to put our faith in images alone; we are such a verbal culture. In representational painting the attraction may be an object or the way light falls on it, or it may be an atmospheric condition or the way the color of a shape is perceived at a particular moment. Whatever it is, keep at it—try not to be distracted by other ideas or images.

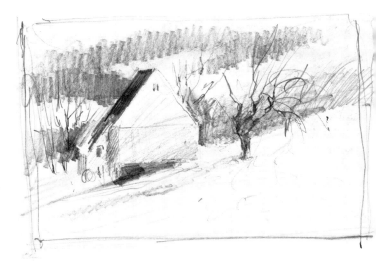

A tonal study of a scene or plan is always helpful. It allows you to adjust the pattern of lights and darks so they visually balance. Balance in painting is seldom rigid or static. It is a matter of dominance versus subordination. What is subordinate should be supportive of the central theme. Balance and unity can be achieved by dominance of either the light or the dark pattern. When connected into a total design, these lights or darks become *masses* of positive or negative space. "Masses" implies a three-dimensional form, which the light or dark pattern has become through the modification of color and value.

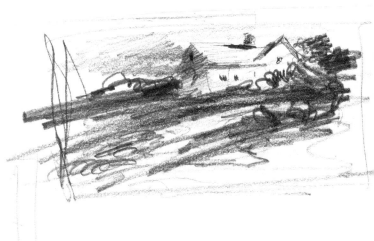

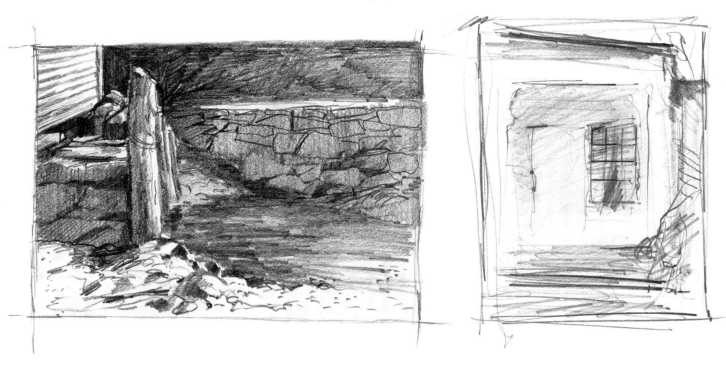

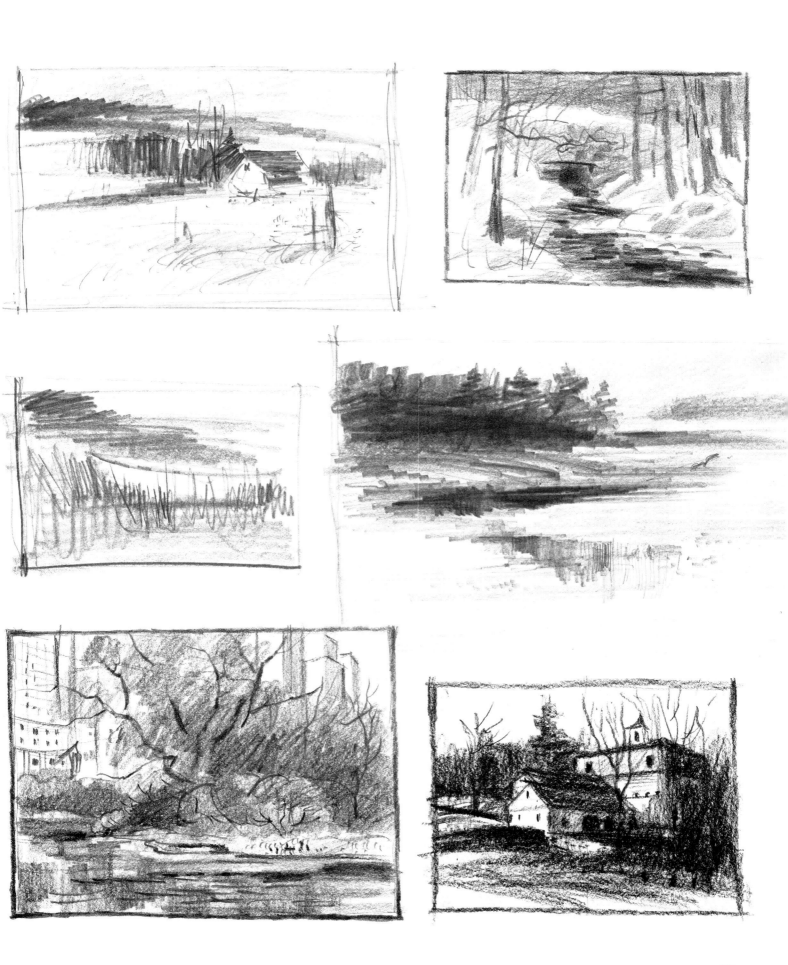

These exercises have proven to be rewarding for both beginners and other students who want to develop their understanding of color and harmony. I practice what I teach, and over the years I have done stacks of them. Occasionally, I get them out like a deck of cards (they are compact, only 5 × 7-inch image size with white margins), and in shuffling them about I am reminded of forgotten color combinations. Reading color theories will not accomplish a great deal. This is a case of visual understanding. These are the basics you have to teach yourself:

- the characteristics of individual colors—their hue, intensity, and value
- the effect of one color on another; how they blend together
- color temperature; warms and cools; their role in aerial perspective, making space come forward and go back into distance
- the emotional impact of color for creating mood and atmosphere

The exercise is composed of four parts. First, do all four in two-color combinations, one warm, one cool. Start with ultramarine blue and burnt umber. Next, for higher intensity of color and warmer neutral shades, substitute burnt sienna for the umber. Payne's gray and sepia make a subtle, low-key combination, excellent for doing value studies. Cerulean blue produces lovely neutral shades when blended with burnt sienna.

Here is the procedure for doing the four exercises pictured in Figure 1.

1. Mask off small rectangles about 5 × 7 inches. Use good-quality watercolor paper; cheap paper will be a handicap.
2. Select your two-color combination. Start with medium-value puddles on your palette. Dampen paper with sponge and clean water to take off surface sizing and make it more receptive. Let paper dry. It should be slightly moist when you start.
3. Stay with your selected color combination for all four parts of the exercise. Begin with A and follow in sequence. Paint freely, using a variety of techniques:
 - flat, mingled, or graduated washes
 - strokes, blobs, spots of color on damp paper
 - transparent glazes over dried first washes
 - variety of brush strokes from dry, dragged to wet
 - textural enrichment: sponge dabs, scrapes, spatter, drips
4. When the work is dry, strip off tape, cut apart, label colors used; file for future reference.

Now go on to three-color combinations—called triads. Don't worry about the combinations; the limit of three choices will contribute to the color harmony, and you will want to discover for yourself what color combinations most satisfy you. You can start by adding raw sienna to ultramarine blue and burnt umber or burnt sienna. With these three you make the leap into almost full color range. If you substitute Winsor blue, you'll see different, cooler color harmony. One of my favorites is cobalt blue, raw umber, and raw sienna. It has "pearly" tones that are reminiscent of early morning fog. Be sure you jot down the colors used because after a while you may forget.

When you peel the masking tape off, your studies will look as finished as if matted. You will find studying the effects you created to be very helpful, even at a later date. The most immediate result will be your assimilation of what each color can do in combination with other colors.

Figure 1

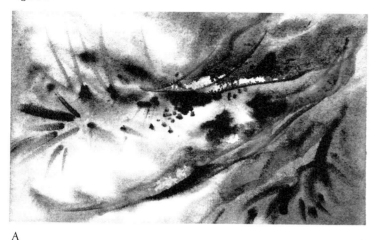

A

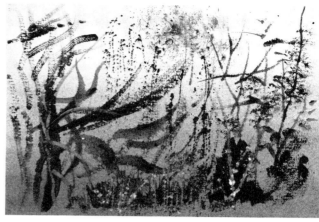

B

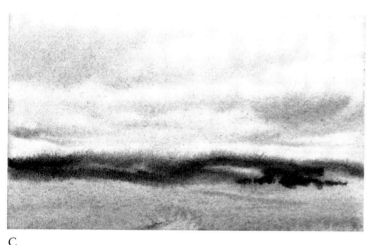

C

D

A. Here is an exercise in pure design. By freeing yourself from painting representational forms, you can enjoy what happens when one color bleeds and mixes into another.

Leave an irregular shape of white paper as you put down colors on dampened paper. Near the white area, place one dark color or spots of contrasting colors and you'll see an activated, focal spot come to life. Work with both wet and dry strokes. Keep the darkest washes transparent so an accent stroke of even darker pigment will show when you paint on top of it.

B. Lightly tint the entire dampened paper with either a flat or a graduated wash. When it is dry, experiment with one or two overlays of washes, flat or graduated. Work from warm to cool. Experiment with

exceptions; I found that a glaze of burnt sienna over Winsor blue gives a luminous glow as in peering below the surface of still water. When dry, practice a variety of brush strokes on top to see the different effects and colors you can create.

C. Concentrate on color and space perception. Omit details. Make three basic divisions of the space by indicating a low horizon line. Leave ample space for aerial perspective in the sky. Make the edge of the background hills the darkest value. The ground area and the sky can be interchangeable in values.

D. Indicate a high horizon line and paint diminishing colors and values to create the illusion of receding space.

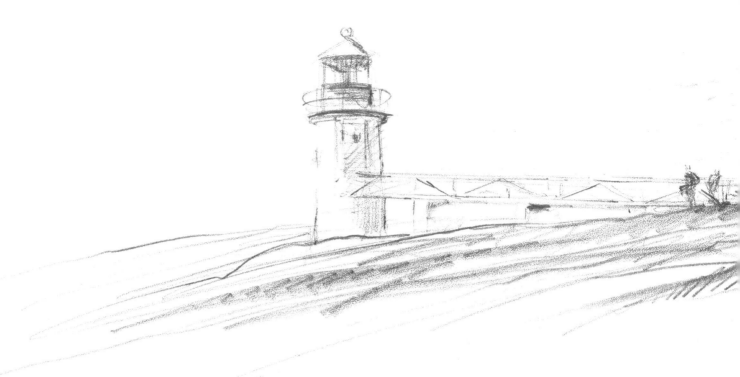

Case Study—Marshall Point Light Station

Here is an exercise in searching out form and establishing the feeling of depth.

There are many variations of point of view that can contribute to the visual excitement of the scene: shown are several possibilities. Notice the contrasts between the curvilinear and angular surfaces; the changes in textures; the variety of edges from hard to soft; and the use of values to suggest form, distance, and atmosphere.

A coast guard light station would not seem a likely place in which to search out a personal concept, particularly at sunset. More as a ritual, as if to pay our respects to some ancient and honorable relative, we amble out to the point, and year after year we become enchanted anew. Some quality of light and weather exists we haven't noticed before, and the transformation is made from the prosaic to something dazzling to our senses. "We've got to get out here to paint!"

Two years ago we walked out in twilight and stayed on to watch the night sky deepen in unusual colors and patterns. All we had with us was one pocket-sized sketch pad and a pen, which we shared so we could jot down our immediate reactions. Such notes can be better than photographs in jogging the memory of the essence of our vision.

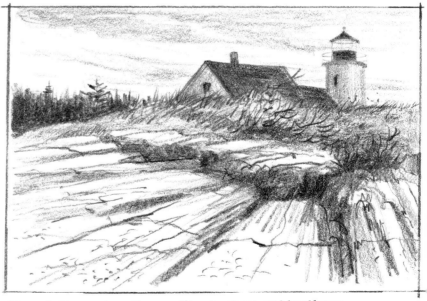

Figure 1. Heavy atmosphere unifies structures and landforms. Diagonal intervals into deep space.

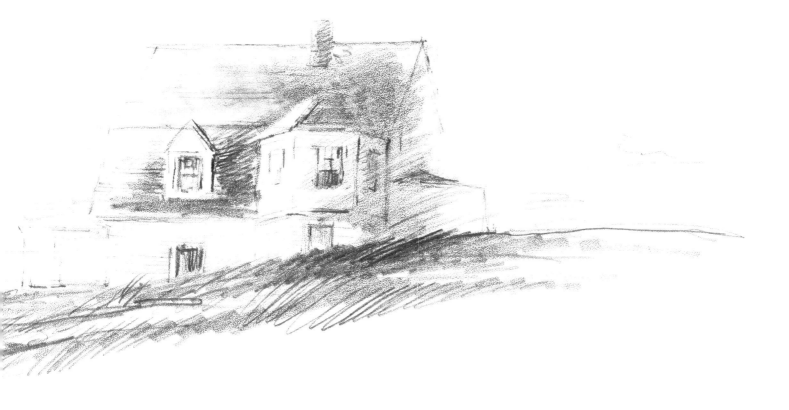

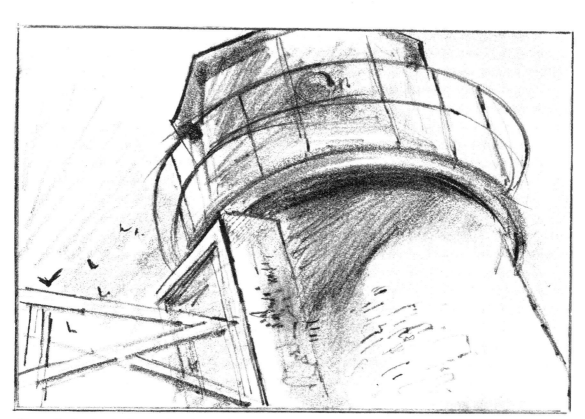

Figure 2. Contrast of curved and angular structural forms. Edges softened by atmosphere.

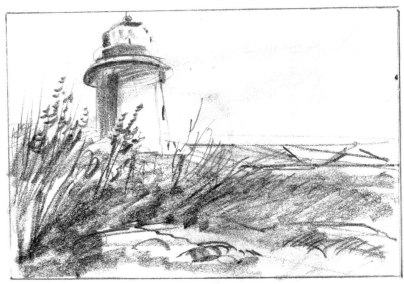

Figure 3. L-shaped basic design.

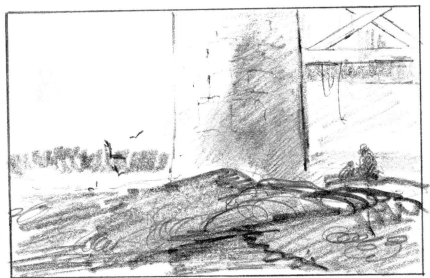

Figure 4. Primary divisions of space vital to this composition.
Low horizon line.
Emphasis of close-up textures.

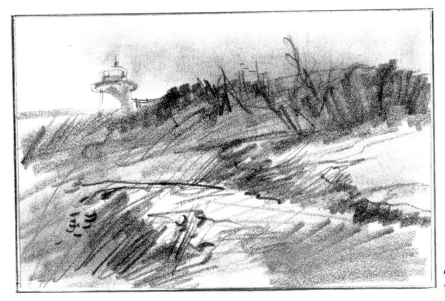

Figure 5. Grassy field is dominant; lighthouse a focal accent.

The Frozen Earth

Winter is the time when the land comes back to itself. . . .

—Anonymous

Winter Pastures / *Murray Wentworth*

This watercolor was done directly on location near my home. I was intrigued by the large broad patterns in the fields. With no preliminary sketches done in advance, I set up the easel and began to draw the shapes rather quickly with a few pencil strokes. This approach is based strictly on intuition and immediate excitement. By taking chances you sometimes achieve your best work, although it is scary at times.

The background was begun by establishing the sky and distance areas, then with bristle brush I began working on the pine trees and fields, trying for a good balance of darks and lights. Meanwhile, the foreground was left untouched. With a 1-inch bristle brush I began building up the grasses using vertical strokes with ochres and umber and raw sienna and adding darker tones as the wash began to "settle," or dry in, slightly. Also with the 1-inch

bristle I added darks by almost throwing the paint on and letting it drip. The texture of lighter weeds was created by pressing the side of my hand into the wet wash. This area is of major importance and could make or break the entire painting; therefore, restraint was necessary in keeping the area simple yet convincing. Note how the detail is brought into the central area.

The painting was immediately brought back to the studio and put in a trial mat. At this point, decisions are often more difficult—there is doubt about if and how the picture should be carried further. After about a week, an unwanted dark blob near the tree on the left was washed out and the area was lightened, along with parts of the background distant woods. Small twigs and weeds were added in the foreground and painted up into the open field to link the foreground and the middistance. This small bit of overlapping helps to unify the design.

The detail of Winter Pastures *shows the areas where textures were created by lifting out lights and pressing the side of my hand, as well as tissue, into the wet paint.*

Detail

*So the bleached herbage of the fields is like frost,
and frost like snow, and one prepares for the other.*
 —Henry David Thoreau

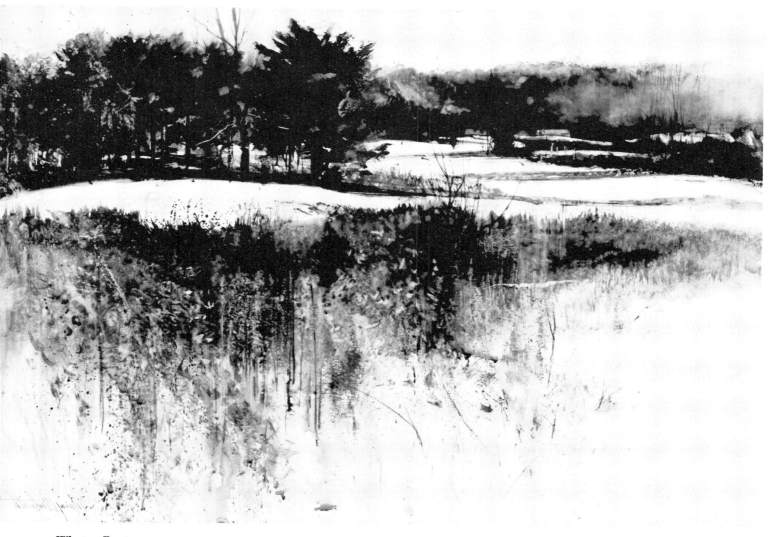

Winter Pastures
20×30 inches, smooth surface paper

Detail

Coastal Thaw / *Murray Wentworth*

This painting was inspired by the rocks on Monhegan Island, off the coast of Maine. It was early spring, and portions of snow and ice lingered in the shaded areas.

The design possibilities of this type of subject are endless, and they always present a challenge of selection. I made rough pencil sketches and took notes on color; they are almost all earth colors. The camera was used to record various shapes of ice around the shore. Later, returning to the studio, I combined photos and sketches to work out a color rough. I first did black-and-white roughs in pencil and then a larger color sketch. The white shape of the frozen area is of the utmost importance to the design, and I knew that how it was treated would make or break the composition.

Working on a 30 × 40-inch sheet of smooth illustration board, I carefully drew in the total positive and negative shapes created by the rocks and ice. Placing all of my darks—background and surrounding rock forms—came first. This gave definition to the massive white shape. Notice how it repeats a sliver of white snow up the hill on the right. I purposely stayed clear of the whites until the massive dark areas were completed and the surface textures were established. To avoid locking in the ice shape, I let some whites carry out the bottom of the composition.

Next, some blue grays were applied to begin modeling form on the ice shapes. These are kept light at first and the tones are slowly built up. Some small bushes poking through the ice help create detail and interest.

After framing this piece and studying it for quite a while, I felt unsatisfied with the values on the snow. Removing the frame, I took a 2-inch bristle brush and with a thin mixture of raw sienna and ultramarine blue I "threw" large washes on the center and let it run down. This delivered the value balance I was looking for. In addition, I added more textures to the rocks and deeper values in the white mass.

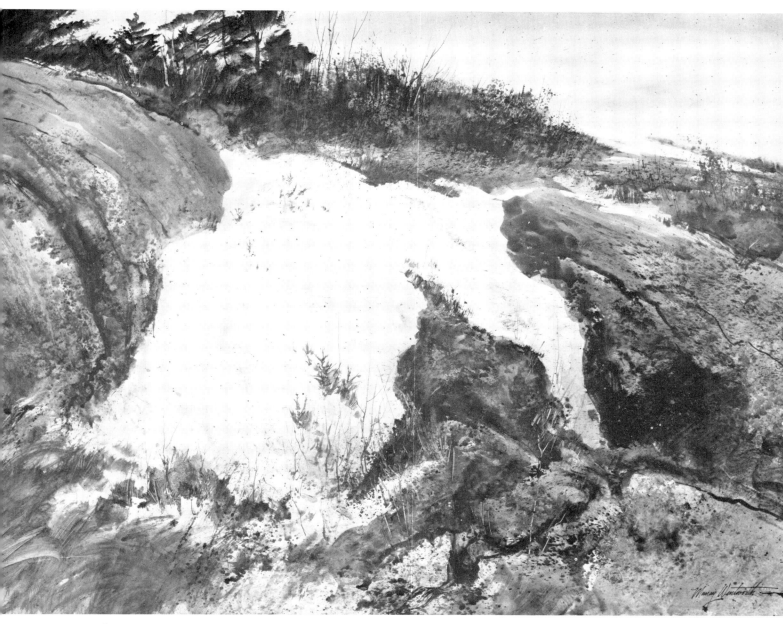

Coastal Thaw
30 × 40 inches, smooth surface paper

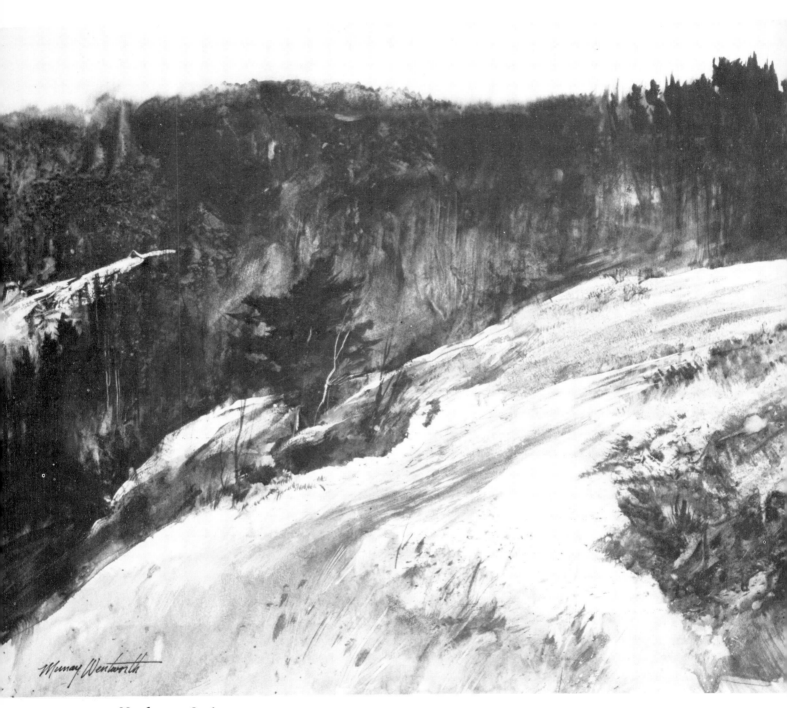

Monhegan Spring
15 × 22 inches, cold-pressed paper

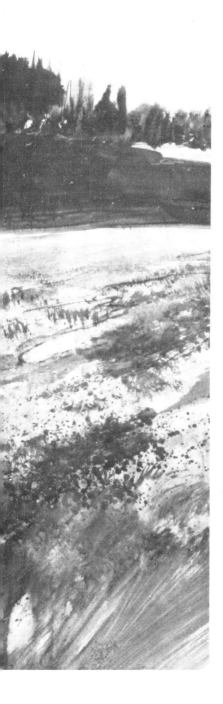

Monhegan Spring/ *Murray Wentworth*

As in the previous painting, this half-sheet watercolor was executed on Monhegan Island during the same spring trip. Again, the dramatic starkness of dark earth and trees accented by patches of snow struck me. Almost immediately I put my drawing board down on a rock and began a fast pencil rough for the large pattern and abstract shape. I then proceeded to paint, using primarily the earth colors and deep, blackish blues. The spontaneity of my approach to the scene allowed me to paint with great excitement. It came relatively easily, as the big overall pattern of darks presented little problem.

The composition is based on two major shapes, and the division of darks and lights must work or the impact is lost. The whites in the sweeping snow pattern are repeated in the distant hills, and a strong dark vertical shape stabilizes the slanting field on the left.

Very little was done to this painting upon returning to the studio; however, I felt the impact of the design lent itself to a bigger painting. Using smooth paper and this painting for reference, I worked up a large watercolor with the same impact and only slight changes in design.

Detail

Frozen Ridge/ *Murray Wentworth*

This painting was done entirely in the studio from various sketches and photos of winter subject matter. The aim was to achieve some interesting textures. The frozen quality in parts of the ice around the ledges was created by using a piece of acetate and pressing the piece into wet washes. I planned the values with a rather rough sketch and let the painting develop as it went along by building up darks. As mentioned earlier, this approach allows for freedom, though to some extent it depends on the subject matter for success. You may be safer in doing more planning, depending on your experience, but try both approaches.

Pressing acetate sheet in paint for texture enabled me to find new shapes while the painting was in progress. This tends to enhance spontaneous feeling.

The spacing of the trees was important, particularly the large mass at the right plus thin uprights to the left and middle areas. I used heavy spattering of umbers at the right for textures and a feeling of looseness. The horizontal direction of the water in the foreground helps stabilize the design. The balance of darks and lights was difficult to keep without making things too busy and spotty. Keep in mind it is better to understate, as you can always add to a painting; it is more difficult to eradicate. An important part of judging a watercolor is to reverse the design in a mirror. By reversing the image the shapes you use can be seen with a fresh eye.

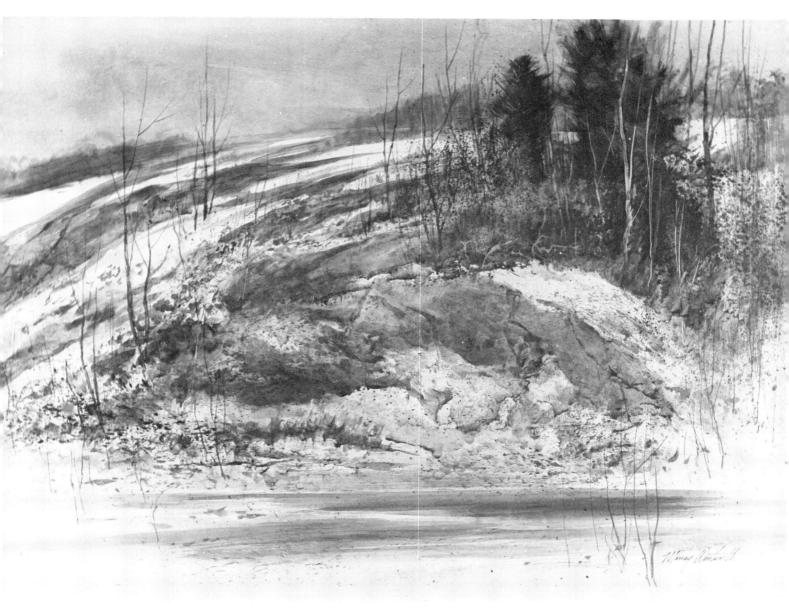

Frozen Ridge
25 × 35 inches, smooth surface paper

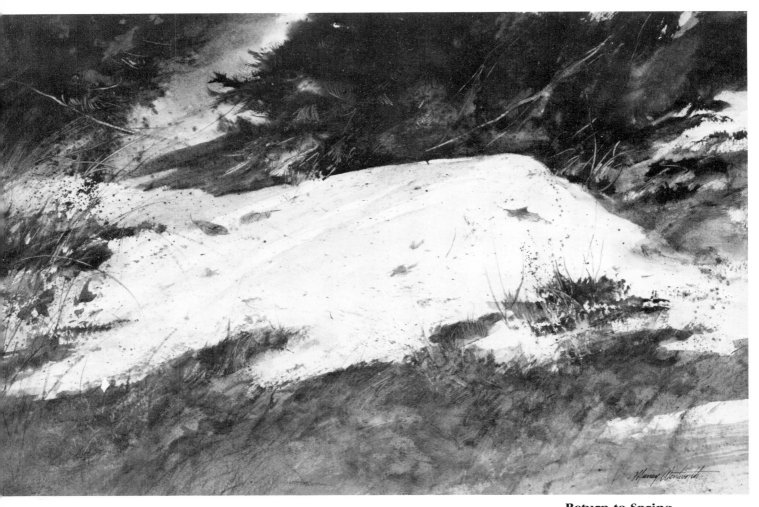

Return to Spring
20 × 30 inches, medium surface paper

At the end of winter there is a season in
which we are daily expecting spring. . . .
 —*Henry David Thoreau*

Return to Spring / *Murray Wentworth*

Some of the best subjects are found right in
our own backyards. One afternoon I walked
out back and came across several interesting
design possibilities in patches of unmelted
snow in the sheltered areas around the
trees.

Looking down at the light shape
silhouetted against the dark, I began a rough
pencil study. I then went back to the studio
and selected a sheet of paper, took my easel
and gear, and quickly set up outdoors.

Drawing in the major shapes, I gave close
attention to the interesting white shape. As
with the painting *Coastal Thaw,* the whites
are the key factor in the design. Using 1-
and 2-inch flat brushes, I began by
establishing the patterns of darks around the
negative white shape, leaving the modeling
within the whites until later.

I carried the painting as far as possible on
location, then brought it indoors and placed
a trial mat on it. After the excitement of
seeing the work develop rather fast, the
difficult decisions were made after some
thoughtful study. Using a small knife, I
scraped out some diagonal branches against
the dark tree mass. In doing this I tried to
be selective, to keep it simple and not break
up the darks.

The Winslow House / *Murray Wentworth*

This painting was done entirely in the studio, using many sketches and several photographs taken in late winter. I have worked many times on this location, mostly in the summer. There are endless picture possibilities around the place for close-up details and a variety of interesting points of view. Here my aim was to capture the lonely atmosphere of winter near the coast.

The composition was planned carefully in pencil. I gave much attention to the snow pattern on the roof, as it locked into the corner of the plane of the house. The lights in the windows are deliberately planned so

as to create space beyond the middle range of the building.

My goal was to paint a solid structure with intriguing atmosphere. This seemed to call for using lost and found edges, so the eye would move within the picture plane and the image would not look stiff and frozen. Many overlapping washes of gray-blue were used on the wooden sides of the structure. When the surface was dry, I wiped out several streaks of light to create the feeling of blowing wind and to suggest a chilly day with light snow. You can always soften a hard edge and rework areas to

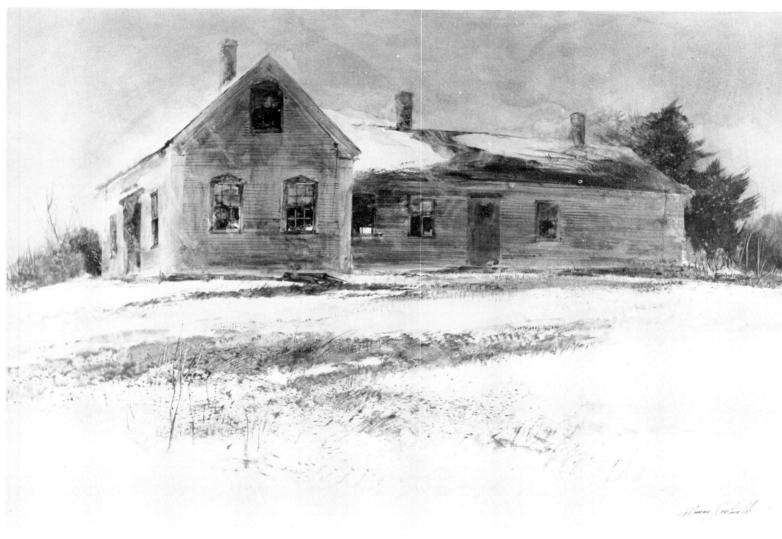

The Winslow House
20 × 30 inches, smooth surface paper

create what is desired, especially when working on a smooth surface. What appears casual and spontaneous, such as in and around windows, actually takes time to build up.

I felt that the sharp edge at the front corner of the house would be too "photographic" and literal. The detail shows how this softened edge helps to tie the near face of the structure to the front side. A slight indication of clapboards is used sparingly to suggest surface texture. Notice that each window is varied in value and design to generate variety and interest.

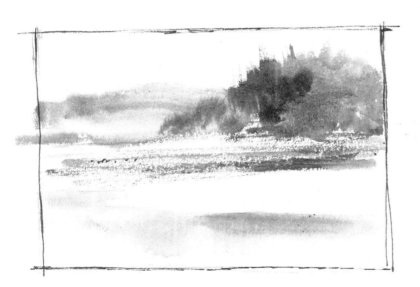

River Ice / *Murray Wentworth*

The ice patterns during a thaw are particularly exciting, and they can suggest many designs and concepts for paintings. This small picture was painted in the studio. It came about after developing several small compositional studies. The subject requires special attention to the dark and light abstract pattern. There are many equally good choices that can be made.

The pencil roughs show two stages, one with emphasis on horizontal ice flow and dark woods behind, the second with more free forms and greater feelings of distance. In the final painting I decided to emphasize distance and work for a deep-space feeling of sky, water, ice, and distant trees.

I developed several larger watercolors from this theme using different design combinations.

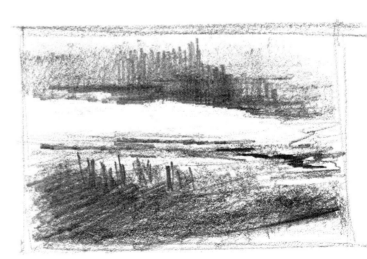

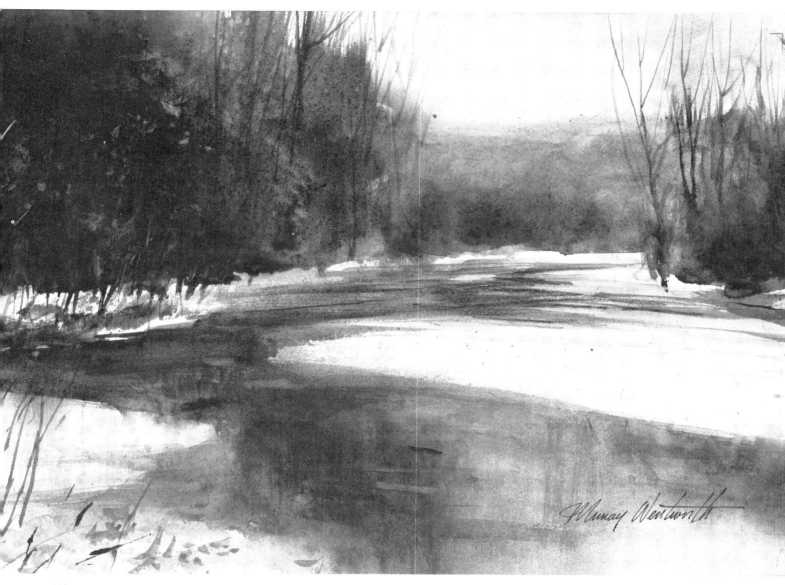

River Ice
11 × 15 inches, smooth surface paper

Frozen Over/ *Murray Wentworth*

I like frozen woodland streams. They are full of exciting picture possibilities. The whites become the dominant factor, making the large areas of light and dark create a visual tension.

By using close values in the major darks of the woods, a shallow space is created that keeps the eye from wandering too far back.

The major dark upright tree acts as an anchor and focal point that stabilizes the composition and holds it together. Adding to the effect is the small white shape around the base of the tree. The smaller upright dark trees were added for variation and to create the illusion of space.

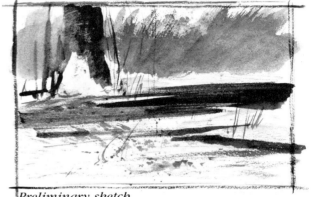

Preliminary sketch

Barnard Valley / *Murray Wentworth*

Generating a feeling of height and distance through darks and lights was the primary factor in this painting. I found this piece a challenge to solve, since it deals with two major areas that are similar in size and shape. The background hill and the foreground almost repeat each other. The placement of the roofs of the barns was crucial. I tried to create tension by letting the lights merge together from the top edge of the foreground hill into the roof plane of the barn. This also creates variety across the sweeping curve of the hill by emphasizing the diagonal.

The major darks of the structure are carried through into the stone wall and grasses in a rather free-form zigzag pattern at the left. These tie together the big dark shapes with the large white foreground. In addition, this pattern leads the eye into the focal area of the barn. The idea is to allow the dark masses to flow into the lights using lost and found edges. Note the barn roof area. As the darks slide off into the dark hills on the left, the hard edges on the nearest corners become more obvious. To avoid monotony, variation is essential when working with dominant lines.

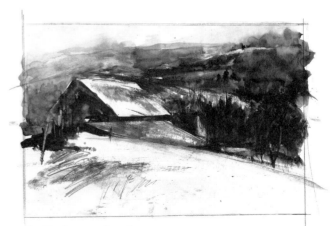

Preliminary sketch

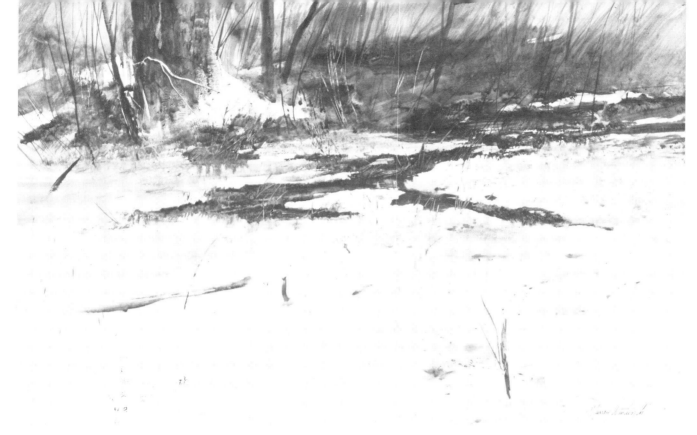

Frozen Over
18 × 24 inches, smooth surface paper

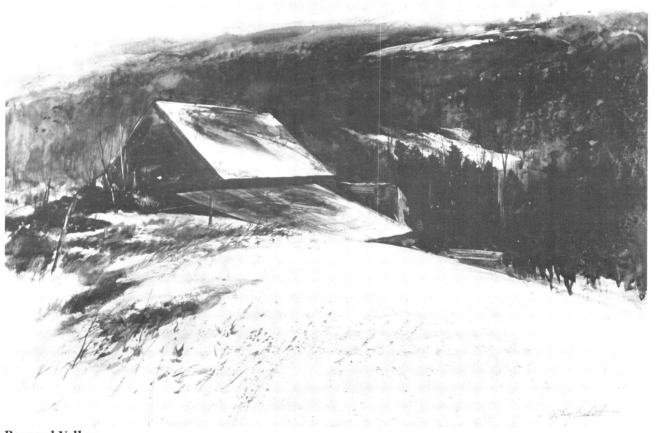

Barnard Valley
20 × 30 inches, smooth surface paper

River Thaw / *Murray Wentworth*

The tidal river basin presents a challenge in horizontal design. I've taken many walks along sections of the river near our home, and find the late winter an exciting time for dynamic shapes that offer a variety for compositions.

This painting was done in the studio using both pencil and painted roughs. I find that looking at the subject for inspiration, then returning to the studio the same day and beginning to paint is the best way to work. It allows me to keep the subject fresh in mind and still work in the convenience of my studio.

The overall value pattern of melting ice and dark grasses is what intrigued me here. It is often necessary to take liberties in shape, form, values, and placement of the real elements you see in order to create a workable picture design. Usually it is a matter of simplifying everything.

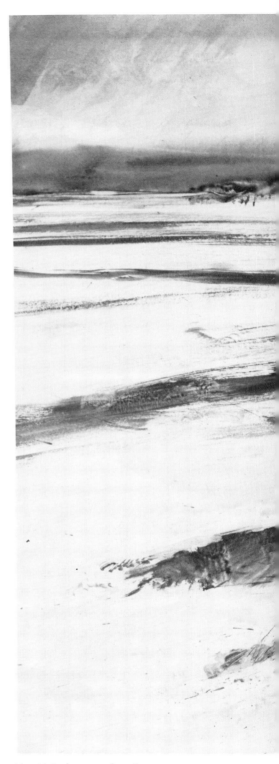

20 x 30 inches smooth surface paper

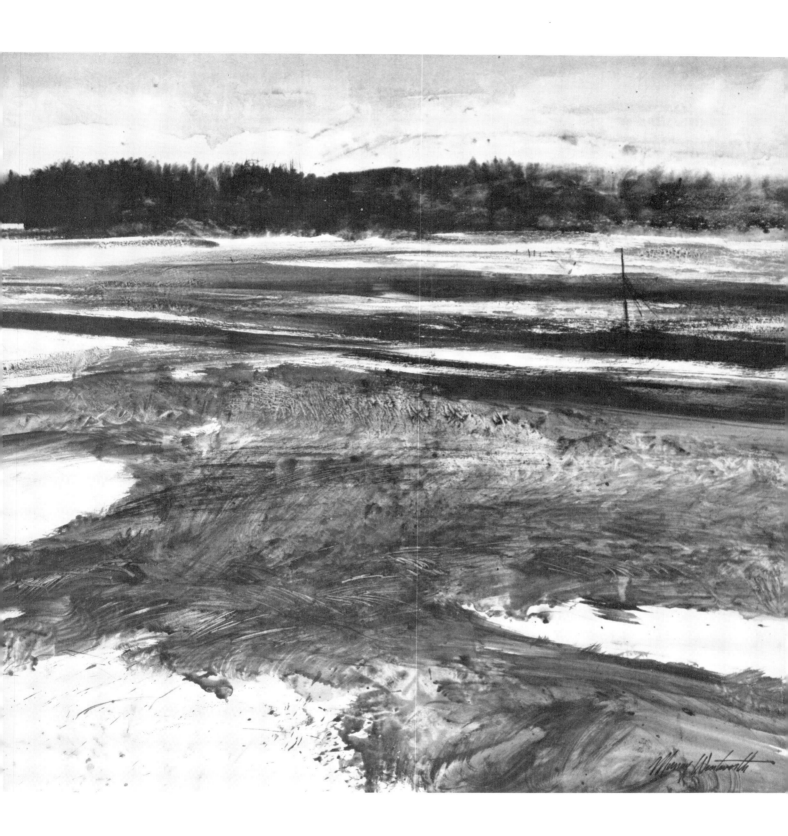

53

Step 1

Demonstration, cold-pressed paper

Murray Wentworth

Step 1. After making preliminary studies, I began the drawing on cold-pressed paper. The sky area was first painted with an undertone of yellow ochre, which was allowed to dry. With a No. 12 round I painted over this with a wash of approximately equal parts of ultramarine blue and cobalt blue, adding a little brown madder alizarin as I went along to create a pinkish glow.

I then established some darks in the background using a mixture of Winsor blue and burnt umber, about equal proportions, and added a small amount of cadmium red to give some warmth to the trees. Later, I also added a small amount of burnt sienna to the blues to create some warm passages in the area.

The white paper was preserved on the hill and in the foreground.

Step 2. A light wash of about equal mixtures of ultramarine and burnt sienna was used to establish the tree shapes at the right middle area. A few light washes around the house and the partial grass areas gave me a value pattern to build on.

With a No. 6 round I brushed a wash of about equal proportions of burnt umber and ultramarine blue onto the roof of the house to define the structure against the sky. (Burnt sienna with ultramarine blue can be used to produce a slightly warmer tone.)

Using a round No. 7 brush, I added definition to the tree at the corner of the house, and with a 1-inch bristle brush I began the bushes at the corner area using about equal mixtures of burnt sienna and ultramarine blue and drybrushing the paint to get the feeling of dry undergrowth.

I then strengthened the roof in stronger values of ultramarine and burnt sienna (almost equal amounts) and dragged the brush across the surface to leave some whites.

The field area was given attention by adding several more washes of raw sienna, with small amounts of blue and burnt umber.

Step 3. Now I add to the sky at the left; the rest is left alone. A cool light wash of Winsor blue was brushed over the top of the distant hills to add a little feeling of depth.

The roof of the house is developed to almost complete values using warmer tones offset with cool areas on the roofline at the extreme left. Whites were left for melting snow settling on the corners of both sections of the roof. Using a wash of ultramarine blue and a small amount of raw sienna, shadows were developed on the house, both front and side. Note the additional wash of raw sienna used on the corner shadows to suggest reflected light.

The trees across the river were built up by additional tones of both Winsor blue and a little ultramarine blue, along with small amounts of burnt sienna. The pine tree was placed at the corner of the house to act as a dark focal area against the white shape of the house. To soften the corner of the building, I added a small woodpile. This also adds a bit of interest and repeats some darks of the bushes. The blues were then added to give definition to the river under the row of trees.

Foreground washes and texture were carried a little further, creating a more defined snow pattern. (Raw umber could also be added to these washes.) A little spatter was used to indicate some weeds near the foreground.

Preserving the whites of the paper is essential, and planning the shapes of snow and grasses helps to ensure the main value patterns of darks and lights.

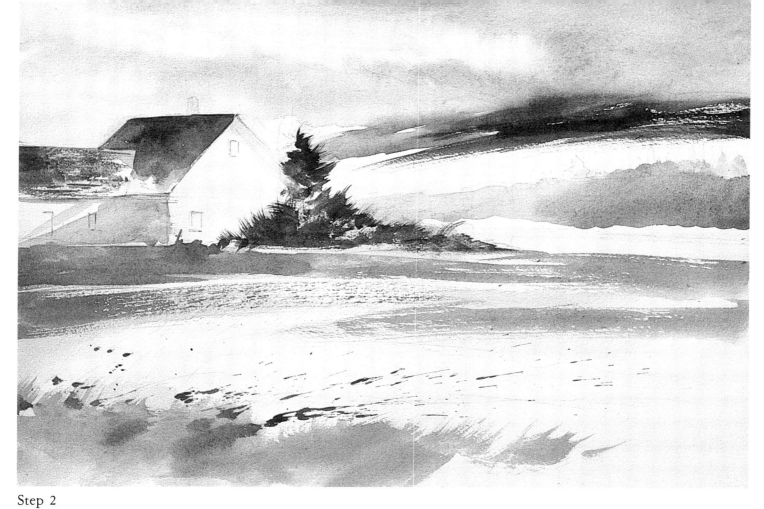

Step 2

Step 3

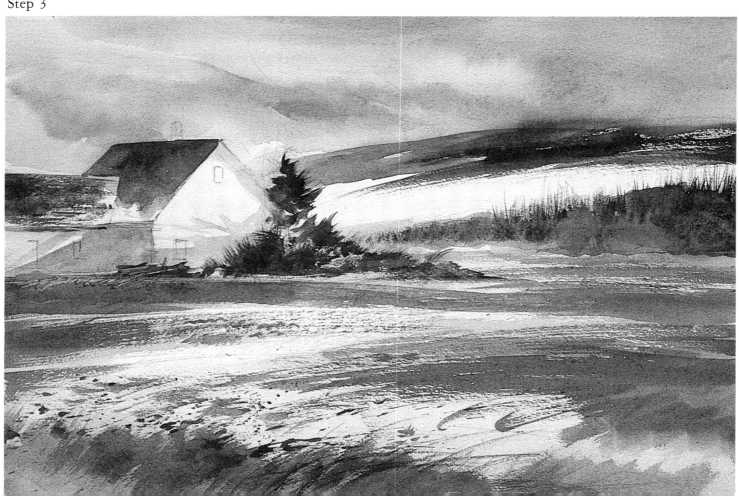

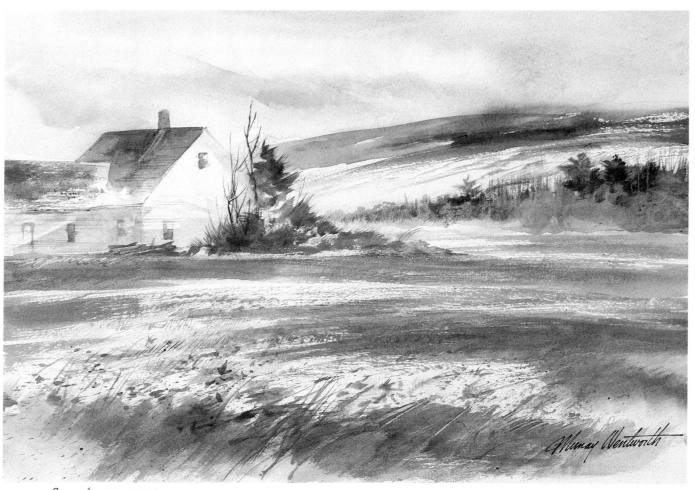

Step 4 *The finished painting.*

Step 4. Some brown tones were brushed across the distant slope, and a light value of ultramarine blue and yellow ochre was used to show a slight change in value where the hill meets the water.

Several pine treès were added to the treeline across the river; also added were several more fine, upright tree textures. Bare trees were placed in the group of bushes and pine tree at the corner of the house. Windows were indicated across the entire structure, and the chimney was added.

I brushed a strong blue-gray value of burnt umber and ultramarine blue on the water to strengthen the area, carefully leaving some whites of the paper.

The field of grass and melting snow was carried further by a bit of drybrushing, and finally, I carefully placed dry weeds in and around the snow patches.

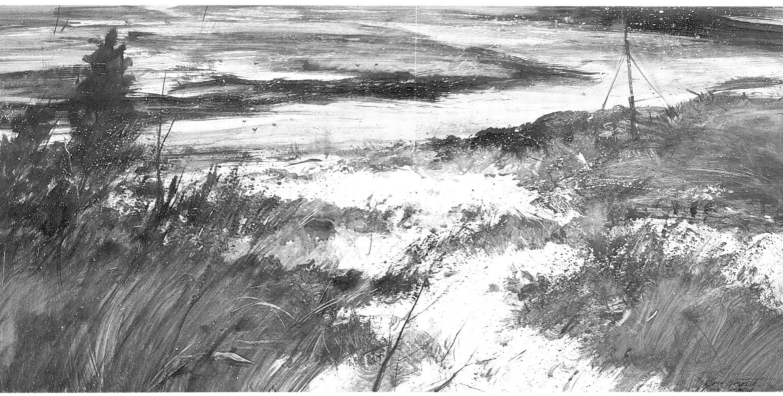

River Snow
19 × 39½ inches, smooth surface paper

River Snow / *Murray Wentworth*

The North River in late winter presents some dynamic design possibilities as the snow melts around the river's edge. This painting was begun in a slightly larger format, but after considerable study, I began to think in terms of length rather than height, so I cropped it down at the top to give more emphasis to the snow and the

section of water. It did not need any more space at the top.

The marker guide for the boats made for a good spot of warm color against the browns.

To give the slight suggestion of falling snow, I used a bit of white paint splatter.

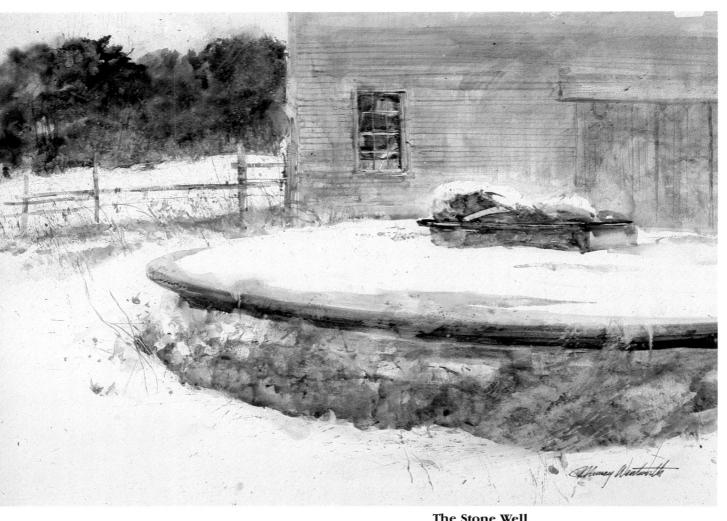

The Stone Well
15 × 22 inches, smooth surface paper

The Stone Well / *Murray Wentworth*

Over the years I have painted a great many watercolors on this nearby farm with its many varied structures, open fields, and fences. The striking contrast of the whites against the barn and well structure has always caught my attention.

During a light snowfall I walked around back and made several quick pencil sketches of this stone well. It was not until much later that this watercolor was done in the studio, using the rough sketches.

The elliptical shape of the well cover against the geometric shape of the barn plus the window created a most interesting pattern.

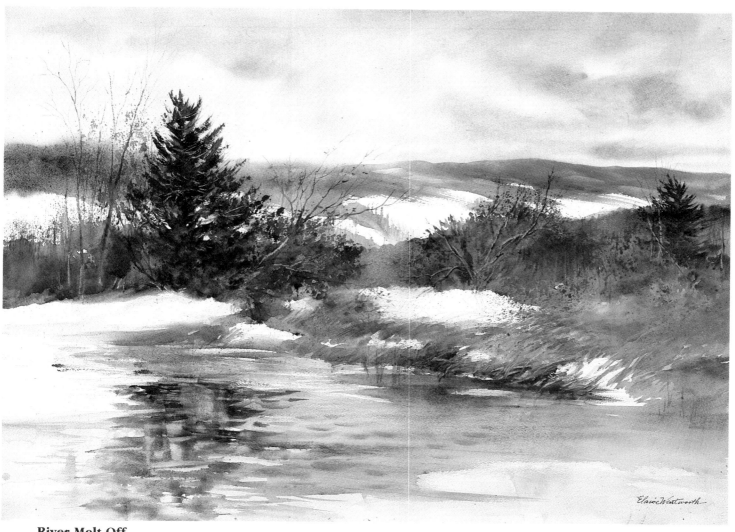

River Melt Off
22×30 inches, Fabriano 140-lb. cold-pressed paper

River Melt Off / *Elaine Wentworth*

After a long cold spell it is exhilarating to
get outdoors to paint in the open again. By
March, in Massachusetts the snow is usually
thawing and there is a hint of spring in the
air. This scene was painted on location near
the North River. The warm colors and the
loosely handled, spontaneous brushwork
describe my happy response to the scene.
The composition is a selected synthesis of
what I actually saw of the river at middle
distance. By bringing the water and
reflections in closer I was able to be freer
with the wet washes. This watercolor is
more expressive of the mood evoked than
an accurate rendition of the locale.

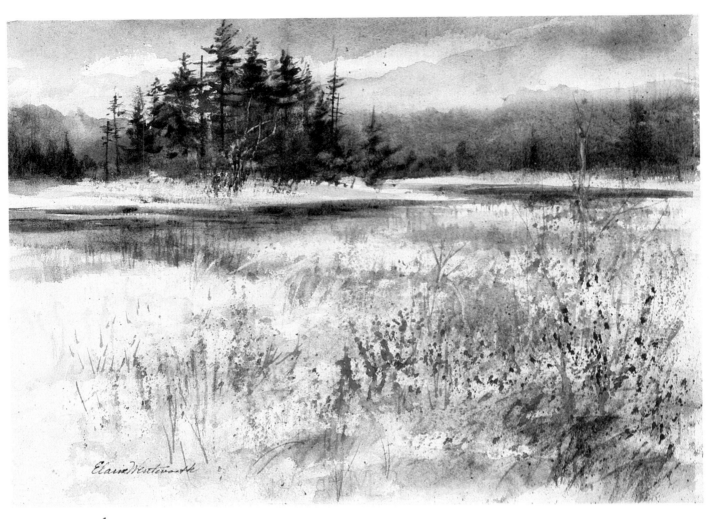

1

Outdoor Winter Studies

Elaine Wentworth

Most of the watercolors reproduced in this section were painted indoors, but I'd like to include some outdoor winter studies. Winter has shifting moods; whenever possible (as long as the temperature is above freezing), I like to paint outdoors. On such outings I usually paint at a reduced size. A quarter-sheet-size paper (about 10 × 15 inches) is more practical for the limited time you can spend outside in cold weather.

Study No. 1 is my favorite bend in the North River and is easily accessible by walking from our house. Although these basic landforms are sweeping horizontals, there are rhythmic variations possible in the patterns of grasses and streaks of snow.

Study No. 2 was painted as I huddled under a shed watching a northeaster approach. Wet coastal storms can creep in stealthily, disguising their potential fury by first turning our world into delicate shell-like hues of rose and blue gray.

Study No. 3 shows the thawing river ice broken into floating cakes, and the vibrant glow of both warm and cool colors reflects the warming sun.

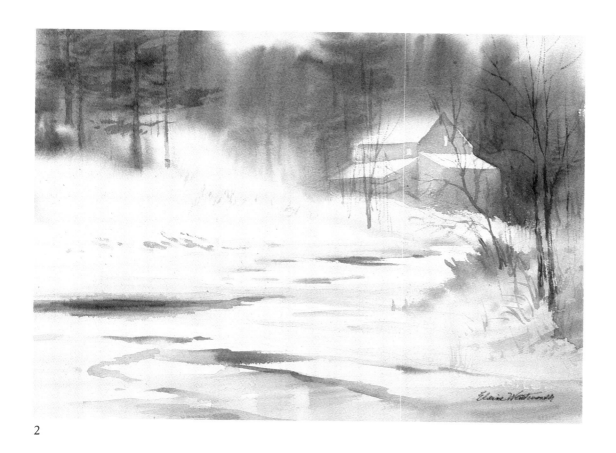

2

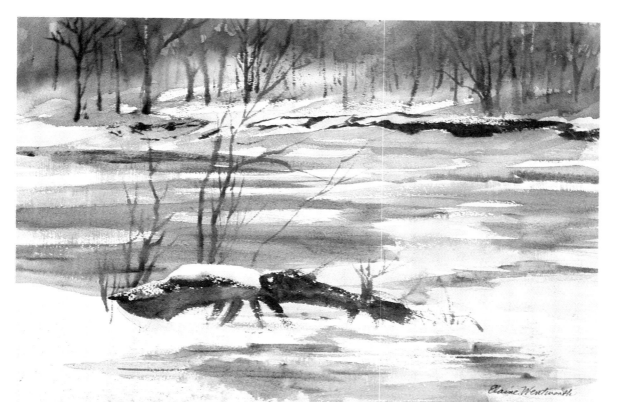

3

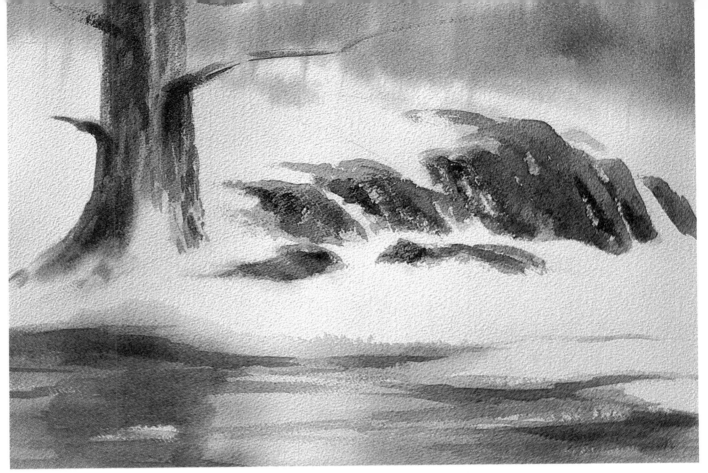

This shows the painting after the initial lay-ins.

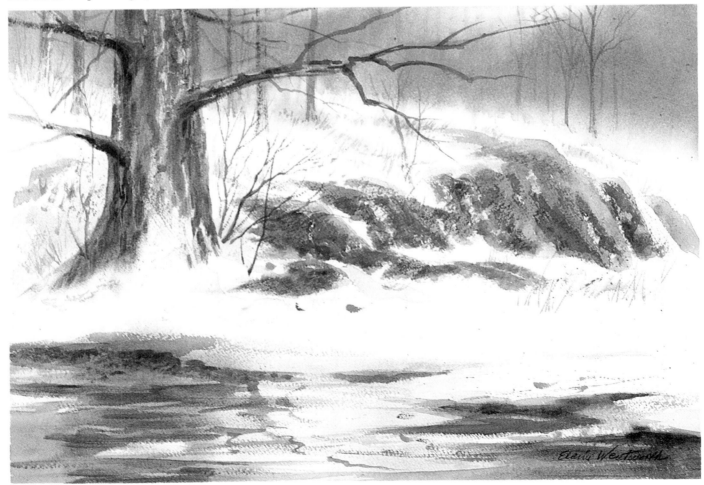

Frozen Ledge
The finished painting.

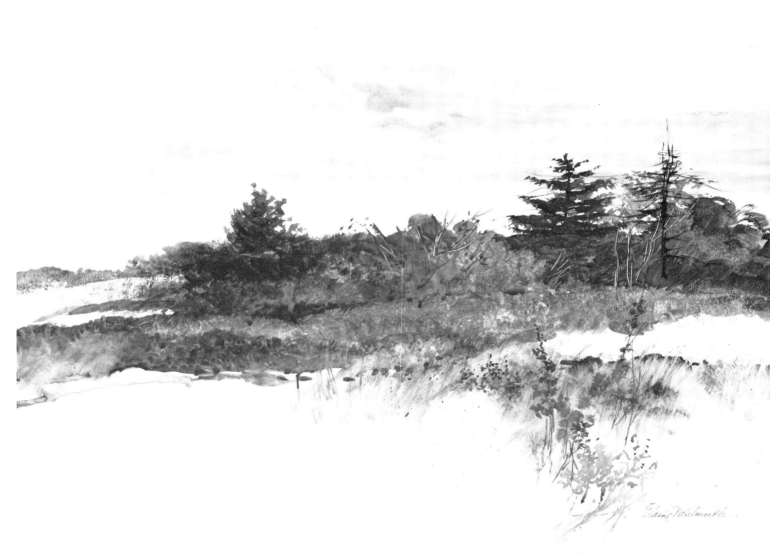

Island Growth
14¹⁄₂ × 19 inches, smooth surface paper

Island Growth / *Elaine Wentworth*

Setting up my easel on the shore facing inland, I only wished to capture the characteristics of the line of trees and shrubs beyond the field. The foreground is merely an introduction to the more detailed painting in the middle distance. The far distance visible on the left is a resting place after viewing the edges of the trees against the mottled "mackerel" sky.

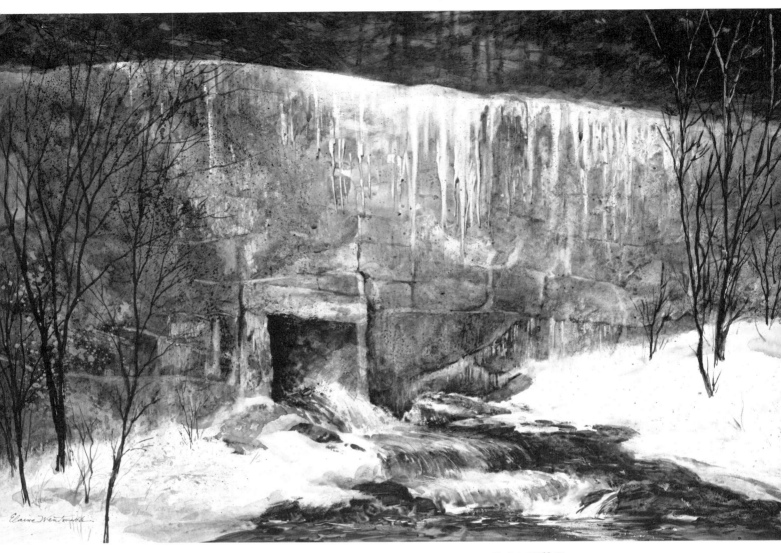

Grist Mill Dam
20×30 inches, smooth surface illustration board

Grist Mill Dam / *Elaine Wentworth*

One day when walking through Norwell's reservation (a parcel of woodland acreage deeded to our town), I noticed long icicles hanging over the dam. I had done many studies in this area, but never one showing a pattern of frozen forms. It was too cold to paint outdoors, so I hurried back to the studio to work from memory. I chose smooth board for more flexibility in lifting out and making changes in the icy verticals. The wall was painted with mixtures of raw sienna, raw umber, and a little Winsor blue. The stone texture was accomplished by scraping here and there with the edge of a credit card. This was done especially

where the values are sharpest. I also used spattering, dabbing with a sponge, and spraying with water. Most of the droplets were lifted out before they dried.

Before painting the rushing water, I went back and did pencil sketches. This enabled me to paint the water with more knowledge. Cobalt blue glazes were added to the wall to deepen the values. There was no sun shining, so the snow shadows are pale indentations of "dirty" yellows and grayed blues. The background blue-greens have passages of brown madder alizarin, which give variety and depth to this area.

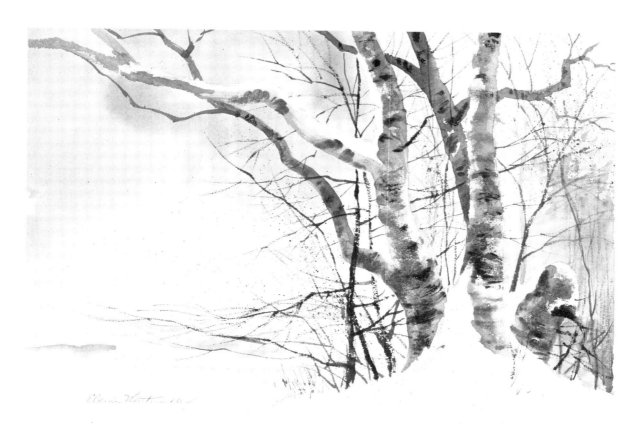

Winter Birches
11 × 14 inches, 140-lb. medium surface paper

Winter Birches / *Elaine Wentworth*

While sketching and painting *Grist Mill Dam,* I kept glancing at the nearby birch trees, especially one particular group. Another day I returned and painted this small study of the trees, but left out all background. Instead, I painted in wet-blended washes of very pale tints of burnt sienna and ultramarine blue with a few flicks of brown madder alizarin. This pale and gentle rosy gray haze is typical of the heavy atmosphere that precedes the onslaught of a northeaster coastal storm. The tree trunks are variations of yellow gray: pale tints of a bit of yellow ochre into burnt umber grayed down with a touch of ultramarine blue.

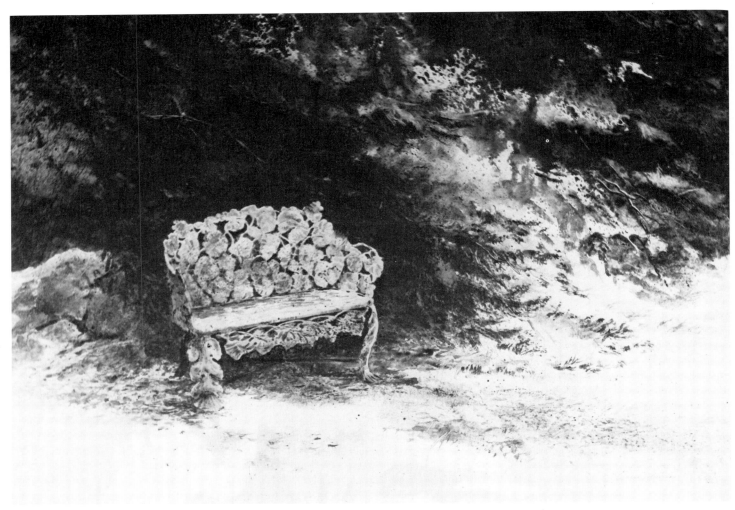

Frozen Lace
22 × 30 inches, smooth surface illustration board

Frozen Lace/ *Elaine Wentworth*

Every time I drive down our street I pass this ornate garden settee. For years I never gave it more than a casual glance. Finally, one fall day, I "saw" it. With a new consciousness I stopped and made a few pencil sketches, which I filed away without developing the idea. Later, after a snowfall, I drove by and was really struck by the similarity of the white ironwork to the lacelike quality of the snow on the boughs. I could hardly wait to paint it!

I chose smooth paper in order to lift out whites and more easily manipulate the frozen lace patterns. I did small color roughs on a Bristol pad, trying to decide on the scale of the settee in relation to the tree. I could have come in close on the settee, but I paused, trying to recapture my initial response—the mood created by the old seat being somewhat diminished in scale where it nestled under the floppy branches

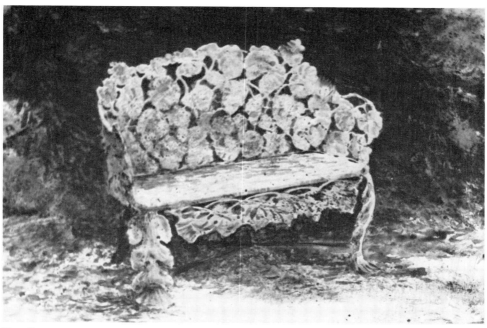

Detail

of a huge hemlock tree.

Considerable time was spent in drawing the settee and its iron tracery onto the watercolor board. The icy pattern on the tree was not sketched in at all. The deep greens were mixed from Winsor blue, new gamboge yellow, raw umber, and brown madder alizarin in varying proportions. I wet the entire tree area with a sponge, then loosely brushed in "minglings" of the dark tones, not knowing how they would run and dry together. The brown madder alizarin tones are more dominant on the far left, giving the effect of looking through the dead branches. While the greens were drying, I crumpled up plastic wrap and dabbed at the paint. This lifted out the color in a textured pattern that looks like crusty ice. I tried this again, keeping in mind that I wanted this texture swirling down the right side with dense greenery directly above the

settee. When the area was dry, I painted back into it with a pointed brush to indicate branch tips poking through the snow. When satisfied that the effort so far was worth saving, I carefully painted various greens in between the penciled tracery and up to the edges of the settee.

The stone wall was vaguely depicted with strokes of grayed blues and greens and a minimum of dark accents for the spaces between the rocks. The texture of autumn leaves showing through the snow was jabbed in more than brushed on, using a combination of a fairly dry brush and a small sponge dipped into pigments. Pale yellow-grays were stroked over parts of the settee, and small accents of rust and ochre were finally added to make it look "settled in" and weathered.

69

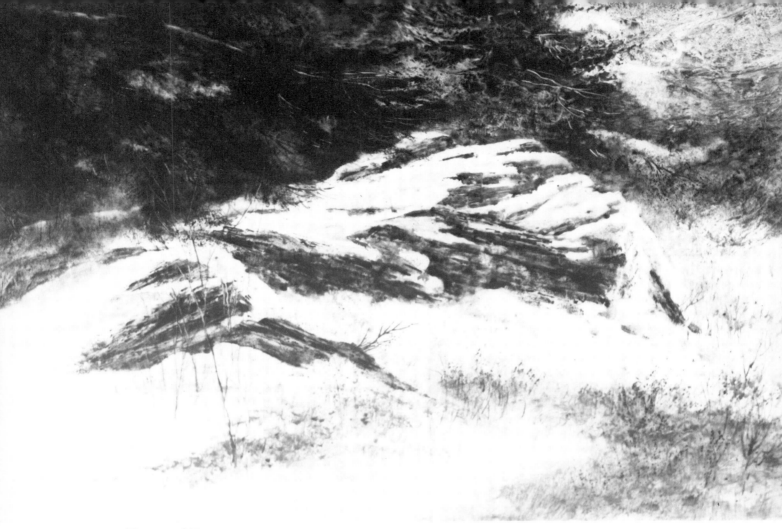

Firewood Two
20 × 30 inches, smooth surface paper

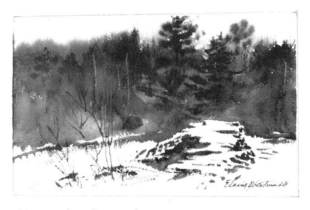

My rough color study

Firewood Two / *Elaine Wentworth*

The essence of this subject is an exercise in Chinese brush drawing. Take a fairly dry brush loaded with dark pigment, and with brief jabbing strokes design a pattern of irregular shapes poking out of the snow. The problem is in deciding which of all these Oriental brush sketches to adapt for the finished full-sheet watercolor. The only way to arrive at a decision is to fill the circular file with variations on the theme.

Complications arise because secondary impressions often assert themselves, diverting attention from the original concept. If the first impression is weak, you tend to welcome new ideas eagerly. With luck they come like snowflakes with endless variations. After making several value and color roughs, which included birch trees, stone walls, and glimpses of back fields, I finally seized the essentials of my first vision—the snowy woodpile a dominant mass against a dense background of soft hemlock branches. Once settled in this direction, I composed the picture within a fairly short time. The color study preceded the full-sheet rendering.

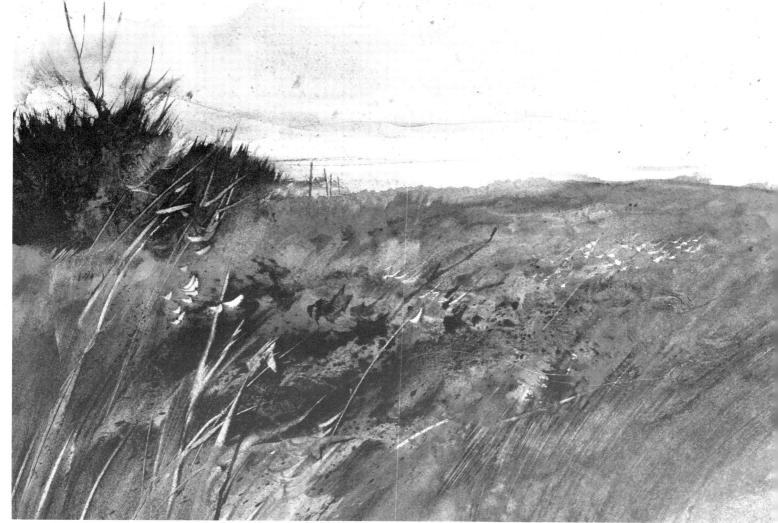

Island Mist
11 × 15 inches, 140-lb. medium surface paper

Island Mist / *Murray Wentworth*

Smooth surface board made textures possible by means other than brush strokes: patting on pigment with side of hand; thumbprints; crunching pigment on with plastic wrap; sponging; spattering; spraying with water and lifting out, then dabbing in again with additional colors. Pale indentations of brown madder alizarin appear, particularly where the lower branches meet the ground. The textures of the wood include some of the above techniques using raw sienna, burnt umber, and grayed blues. The foreground grass was washed on casually with raw sienna and burnt sienna grayed with ultramarine, then textured with drybrush strokes, spatter, and a few definitive weeds. Soft shadows are mixtures of raw sienna, blue, and umber.

It was a bright misty morning that I did this painting. The scene is typical of conditions along the shoreline. The brightness is achieved by the contrasting values on sky and grasses against the pure whites of the paper in the water area. Descriptive textures were added in the foreground for interest and to create scale.

The light weed pods were scraped out of the wet paint with the end of a beveled handled brush, and the small light flowers in the right distant field area were picked out with a razor blade. This actually "lifts off" the paper surface after the area has completely dried.

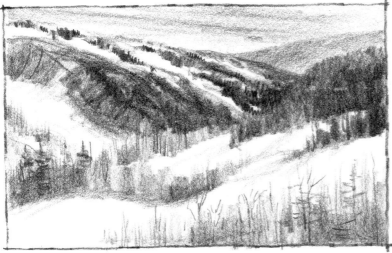
Figure 1

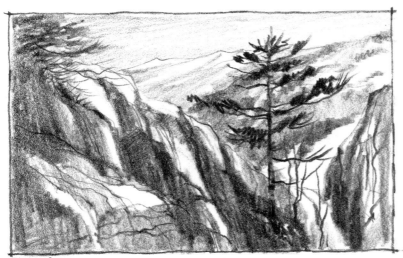
Figure 2

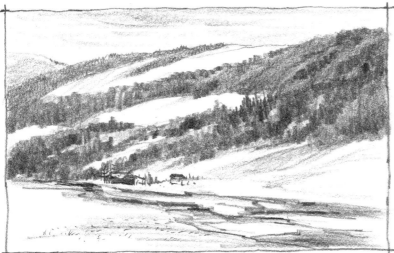
Figure 3

Climb the mountains and get their good tidings.
—*John Muir*

The Rolling Hills / *Elaine Wentworth*

The upward swelling forms in Vermont are a delightful change from the horizontal planes of salt marshes. For mile after mile the gentle overlapping hills propel your vision to new summits and downward sweeps. The color is wonderful in all seasons. In winter the grayed pinks of the deciduous trees contrast beautifully with the deep evergreens.

This is ideal terrain to sketch while traveling by car. Try it wherever you travel (with someone else driving). My sketch pads include dozens of pages of quick sketches inspired by the passing roadside scene. Some of these are no more than a few lines, yet these symbols activate my memory more effectively than a photo. You can jot down color information in the margins. Strive for the substance of what you see; ignore details—just put down broad essential forms.

Figure 1 is viewed from a high vantage point, looking across the tops of trees. Figure 2 is the result of the highway cutting through vertical ledges where crevices of ice and snow can be viewed close-up. Here a quick glimpse into distance diverts the eye from the strong frontal plane. There are many variations of abstract patterns in these formations; from them you can develop a series ranging from geometric and free form to intimate nature studies.

The bottom sketch (Figure 3) shows the long vista you see while riding alongside a river as you glide along a flat valley. The rounded hills always carry an interesting patchwork of forest and fields. Whatever time of year, there is much to please the eye and suggest exciting picture possibilities.

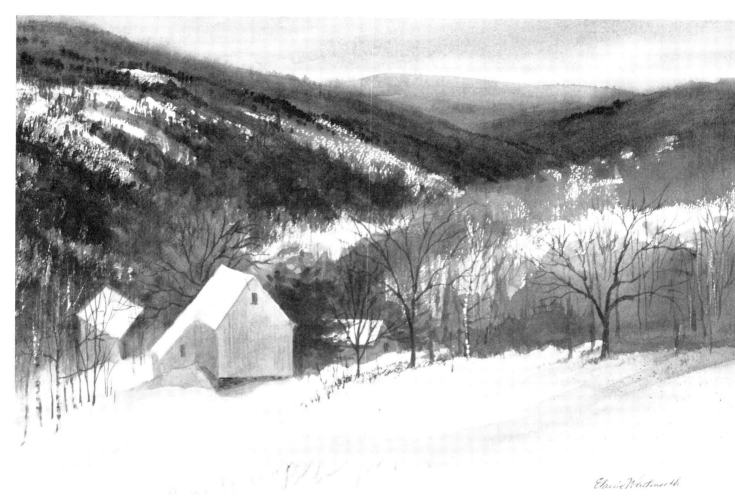

Spring Thaw
10x14 inches, 140 lb. medium surface

Spring Thaw / *Elaine Wentworth*

This small watercolor was painted on location during a short stay in Barnard Valley when the sun shone on melting snow and we were able to paint outdoors in shirtsleeves with our feet and easels sinking ever deeper into the slush.

Snow crystals have great reflective power. At noon the sun gives the snow a warm glow of pale ochre or raw sienna. On a sunny day the shadows are blue, especially where they slide under the evergreens. It is amazing to see the intensity of this hue. On more overcast days the shadows fade into "dirty" yellows. To emphasize the snow, the sky is better toned down in value. Because spring was approaching, the deciduous trees here were showing soft pinks and mauves.

The background is broken with patches of snow. These fall away into gradations of values with soft edges, a watercolorist's delight. Hard and soft edges are vital here. In such a rendering, one broad washstroke can indicate an entire row of trees, providing the edges work effectively.

Notice the lower row of trees; the top edges end in dry-brushing, the bottom edges are less agitated, but have two definite breaks to relieve the long, sloping passage. Colors used were: Winsor blue, raw sienna, a touch of burnt umber for cool dark greens; brown madder alizarin with bits of burnt sienna and cobalt blue for tree masses, and cobalt blue warmed with the brown madder for the sky and distant mountain. Foreground shadows are pale Winsor blue with a touch of the brown madder. The overall color harmony is cool with the sun momentarily behind the clouds.

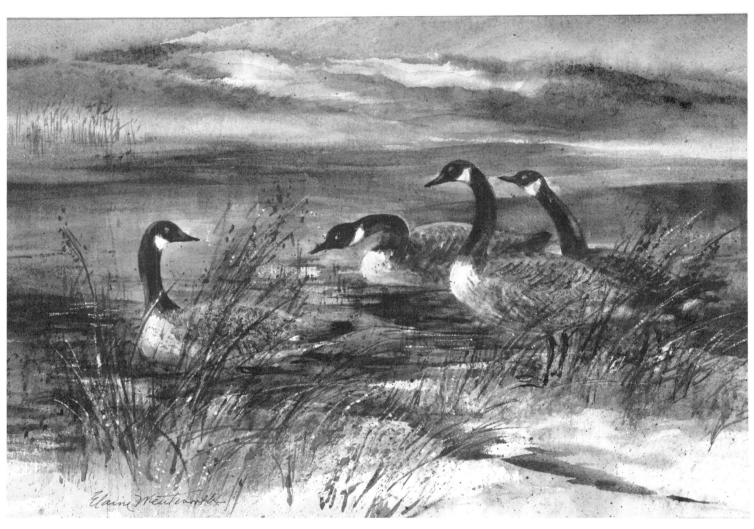

Wintering In
10 × 14 inches, 140-lb. medium surface paper

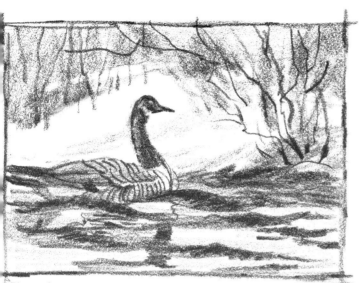

Figure 1

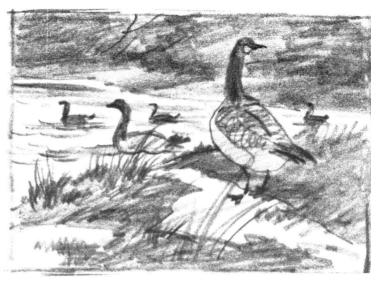

Figure 2

Wintering In / *Elaine Wentworth*

Once the Canada geese dropped down onto the grassy marsh of Amrita Island, Cape Cod, they stayed, admired and catered to by several ladies including my mother, who also wintered in on the island one year. That meant on visits I could sketch geese to my heart's content. (The island is accessible by car over a quaint fieldstone bridge.)

Here I'm trying to contain the landscape within a pattern that is subordinate to the geese. The color harmony is basically grayed blues, burnt umber, and raw sienna. The foreground grasses have a few flicks of burnt sienna. Raw sienna appears in the dunes, glazed over with washes of pale

cobalt blue. It is not necessary to use black for the geese; ultramarine blue and burnt umber make rich darks.

In Figure 1 the colors are higher-keyed: pinks for the background haze of bushes, Winsor blue and raw sienna mixtures for the rippled water, and grayed pinks for the slight surface water tone. In Figure 2 the grass and patches of snow can be designed in unlimited patterns of positive and negative space around the geese. The waterways offer another element full of spatial divisions where arbitrary patterns can be conveniently developed to suit the purposes of your picture.

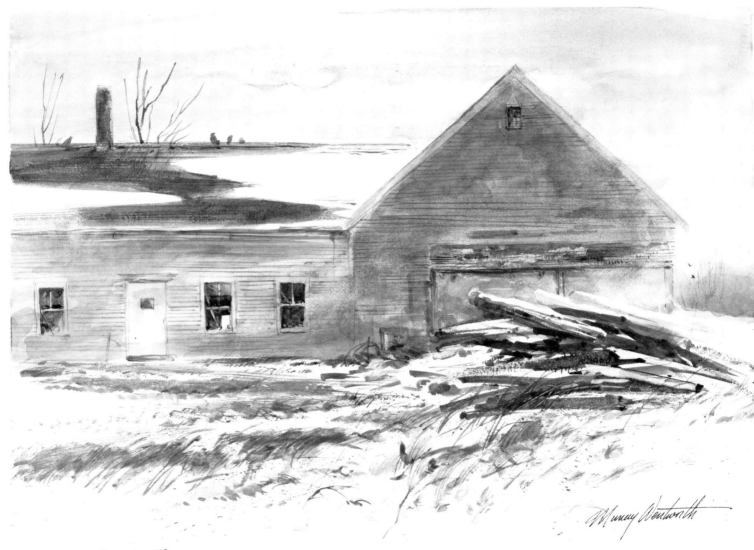

Country Place
11 × 15 inches, smooth surface paper

Country Place / *Murray Wentworth*

Once this classic old house was a working farm. It remains in excellent condition. I have driven by many times, both summer and winter, and it always arrests my eye as an exciting theme. Over the years I have completed several paintings from various points of view in the vicinity.

Subtle pinkish-gray tones are used on the face of the barn and blue-grays and yellows on the white part of the house. Yellow ochre tones are evident up under the eaves for a warm reflected light. These then change to silvery bluish-grays and yellow ochres across the face of the structure, around the windows. Careful placement of the open window on the back side moves the viewer back into space and creates interest as well as tonal variation.

The Sun Returns —
Spring and Summer

In those vernal seasons of the year, when the air is calm and pleasant, it were an injury and sullenness against Nature not to go out and see her riches, and partake in her rejoicing with heaven and earth.

—John Milton

Morning Walk / *Elaine Wentworth*

Woodland interiors have enchanted me since my treks through the rain forests in Alaska. Every day I see variations on this subject from the northeast windows of our home. At dawn a pinkish-orange glows through the trees, and in the evening soft mauves appear. The changing light that sifts down or bounces across the trees is what makes the scene so tantalizing.

The Maine woods, where *Morning Walk* was painted, are different. Tall spruce trees, rather than pines, are more characteristic of the area. The cool morning light glided across the massive birches as I walked down the path from the camp. I wanted to capture this before the light changed, so I ran back for all my painting gear. Unfortunately, considerable time elapsed before I could actually begin painting, but the effect was still enchanting. When I stepped off the path, the boughs closed around me. I felt surrounded. The only light was from above, shifting and flickering downward through the tall trees.

For my painting I decided that the dominant area would be the grouping of birches against the darker trees, still wet from the night's sea fog. As I broadly brushed on a variety of greens, I left a reverse L shape of white paper for the birches and a streak of light to identify the ferns and undergrowth.

Greens originated from puddle mixtures as described on page 87. I made greens from ultramarine blue for softer tones and from Winsor blue for sharper tones, and I used a little raw umber with the Winsor blue to create transparent low-keyed woodland shades. Here and there burnt sienna or brown madder alizarin was mixed with a little viridian to make subdued tones. Light greens came from new gamboge yellow with small amounts of cerulean blue. An upper left area was barely tinted so that light would sift down in a vaguely flowing shaft that could be modified later.

Only through direct observation could I have imagined the subtle gradations of color that flickered in and out of shadow. In some spots broken color—warm and cool—vibrated on the tree trunks. The warm tones, basically a red violet, were mixed from brown madder alizarin with a touch of Winsor blue. In other spots the trees were shaded with such exquisite coolness that several blues and viridian were needed to capture it. (The blues, Winsor or cerulean, were cooled with a little raw umber.) Although viridian is intense if used full strength alone, as a glaze over other colors it creates a subtle gradation of coolness. Viridian mixed with varying amounts of complementary colors, such as alizarin, brown madder alizarin, or burnt sienna, makes lovely neutral tones. Experiment with neutrals (or grays) made with complementary colors, such as cerulean blue with cadmium orange.

An elusive push and pull quality of color and value balance would have kept me standing at my easel all day, but the light rather quickly shifted from the birches long before I was finished. I decided patience was called for and packed up my gear. The next day I was back at the same time. Gradually, I built up transparent washes on the birches (cerulean and orange were used here), going back and forth from them to other sections, evaluating and adjusting the edges of the birches from hard to soft, from sun to shadow. Drybrushing with greenish umbers helped to identify the tree markings.

It is difficult to describe the process of trying to achieve a cool, mysterious quality in a painting. Here I kept a taut control of the color harmony—nothing *too* dark; nothing *too* bright—and finally added sparse transparent glazes of cobalt blue and viridian. My goal was to create a strong painting, not just a pretty scene.

Painting a pink and orange dawn glowing behind silhouetted shapes is simple once the trees have been carefully positioned. A similar effect is sometimes evident when you see the intense blue of the ocean vibrating in the distance behind and between the trees. Bright color poking through "holes" in a dark foreground must be treated carefully. You can't let them "zing" right up into the foreground, where they would overpower the composition.

An early morning walk is a blessing for the whole day.
* —Henry David Thoreau*

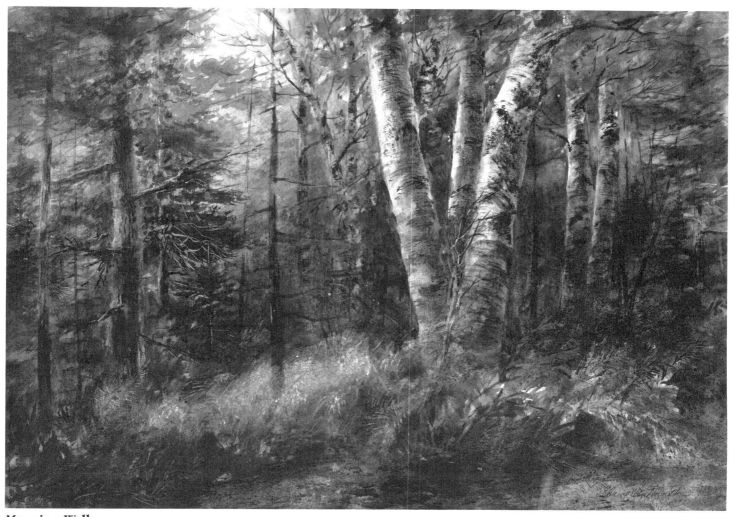

Morning Walk
22 × 30 inches, 140-lb. medium surface paper

Sun and Mist / *Murray Wentworth*

This painting is a good example of using three values to produce a strong design. Here the darks dominate the lights. Care was taken to keep the shadow side of the building simple in value, broken only by the dark window shapes.

Pure white paper was left on the left side of the structure and repeated through the top window to push the viewer back into space and create variation. I believe this simple value range enhances the feeling of a warm sun prevailing.

The dark tree at the left concentrates the strong value contrast in order to emphasize the structure and contain the composition. Small descriptive textures of weeds and flowers are used to suggest height and scale in the scene. Cropping the building at the top also helps contain the interest and makes the building seem larger and more important.

My pencil rough

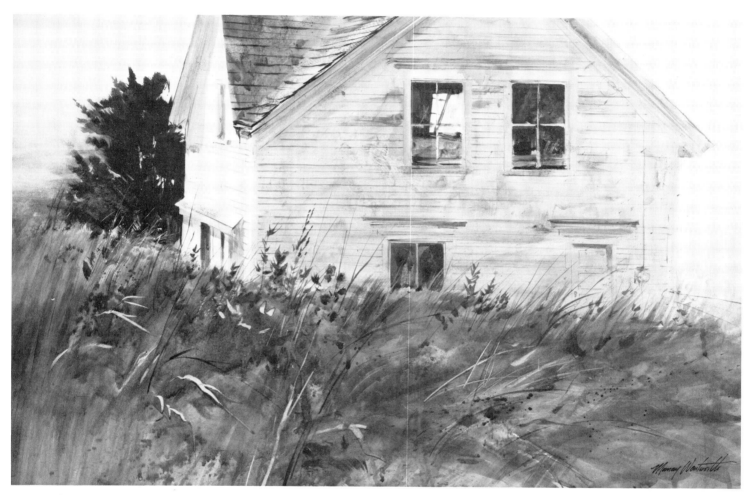

Sun and Mist
20 × 30 inches, 140-lb. medium surface paper

Country Kitchen / *Murray Wentworth*

The warm sun created strong design possibilities inside the old grange kitchen. I am constantly searching for interesting interior subject matter and found this ancient Grange Hall to be most fascinating. The building is used mainly for church suppers, special meetings, and functions and is therefore empty quite often. We have used this hall many times for our Maine workshop classes during inclement weather, and the students have been inspired by the varied subjects in and around the building. The kitchen area has been filled with students working on tables and counters, and easels have been set up in the entranceway as well as in the main hall. The ocean is visible through the large kitchen windows.

I spent almost an entire day in the kitchen making preliminary sketches related to the finished painting. The next day I returned from our camp to begin working out the final stages of the design and start the painting. The light was just right: the bright sun casting shadows over the old wooden cupboards made dramatic highlights across the geometric shape of the doors and balanced well with the natural light from the window on the right. I felt that the shifting shadow patterns helped make this geometric design more interesting.

The light tones on the dish towels against the cupboard helped carry over the continuity of light from the left to right side of the painting. Detail and textures such as the old hinges and the grooves in the wood were added after the entire value pattern began to work satisfactorily.

The painting of the white water pitcher on page 117 also originated from the setting. The pitcher was sitting on the old sink under the kitchen window. It was a nice isolated still life just waiting to be painted.

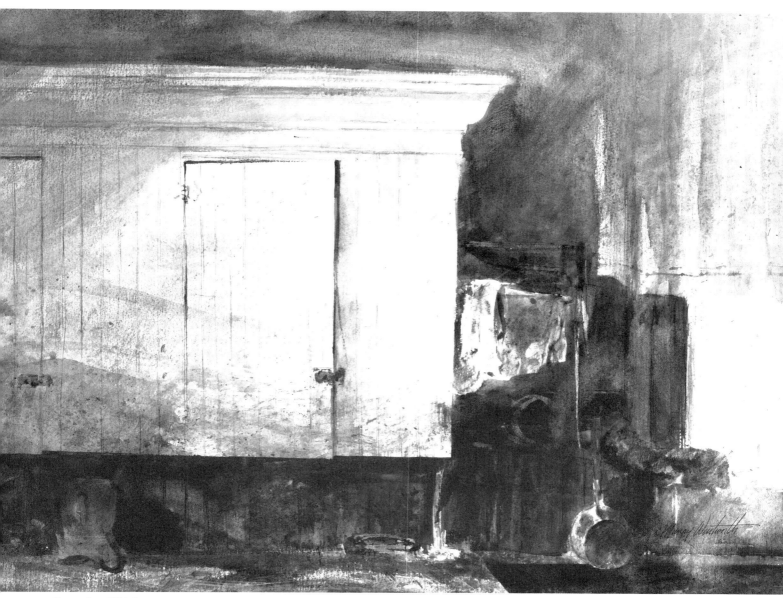

Country Kitchen
15 × 22 inches, 140-lb. medium surface paper

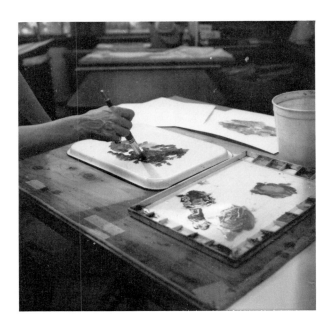

Monoprinting

There's nothing new about monoprinting; it's been done a long time. Both Degas and Rembrandt, for example, made some beautiful prints. I feel it is a good means to pull any of us out of the repetitious rut that a constant diet of standard watercolors may lull us into. It is a great way to open our eyes to new visual imagery. Monoprinting gives you a new freedom without "sweating your mind." No passports needed; no traveling time to exotic ports—all you need to gather are your regular watercolor supplies, smooth paper, and a smooth printing surface.

The monoprint is basically an offset transfer print. A large slab (any size; 16 × 20 inches or larger is convenient) of Plexiglas makes a good lightweight surface, or you can use Formica or regular glass. Smooth paper offers the greatest variety of textures. Cut up plenty of paper to a size appropriate

for your printing surface. With two strips of masking tape, make a registration right angle on the upper left corner of the print surface. Place the corner of the paper within this guide each time you print. It is not possible to create the same image more than once, but with a degree of control you can achieve variations on a theme.

First, brush a few blobs of color onto the printing surface using any of your brushes and whatever colors you like. Keep the pigment fairly thick. Only by experimenting will you discover how thick or thin you want it. After you see what can happen, you can place your paint in a planned position. You will never have total control of the situation, and that's the mind-expanding fun of it all! The results—free, organic, sometimes suggestive of microscopic studies—can open up new possibilities for creative expression.

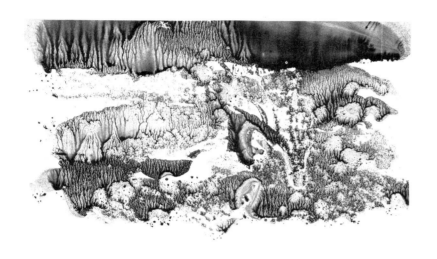

Here's the procedure: Place the paper into position and press down and rub across with your hand. How you do this doesn't seem to matter, but how you peel off the paper does. If you lift from left or right, the textures will take on a directional slant different from peeling the paper from top or bottom. You will be amazed at your "ready-made" creations in line, form, mass, color, and texture.

You've probably already grasped how you can interplay this with your brushwork in your "painted" watercolors—take a little scrap of acetate and press it into the paint on the print surface, then rock it onto your watercolor in certain areas for textural richness. You can then go back into these areas with brush, sponge, scraping edges, hands—whatever—to further develop them and astound the viewer.

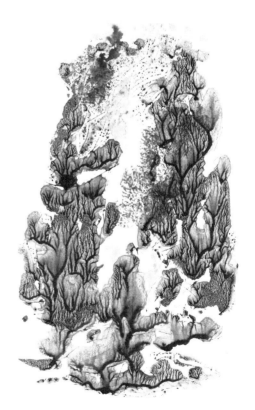

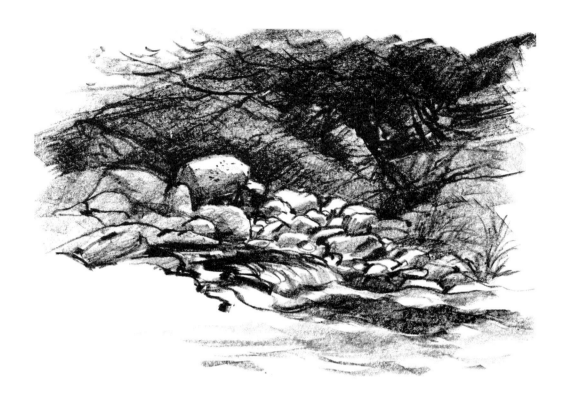

Demonstration

Elaine Wentworth

When growing up, I thought of hot bright days as "beach days," but now I take to the woods. Here the intensity of the summer sun is shattered into sparkling facets of color set against the cool depths of the forest. In sunlight the shallow water of a brook runs rich in tea color, reflecting warm sand beneath the surface. The woods and undergrowth are accented with spots of light green, rusty reds, and viridian. Dried twigs reflect light and appear almost white; massed together, they tend to become a red-violet haze. A close-up view of this domain is rich in design possibilities. Deeper space can be implied with small patches of light in the woods or by reflections in the stream. Summer sun in the woods can be a watercolorist's delight.

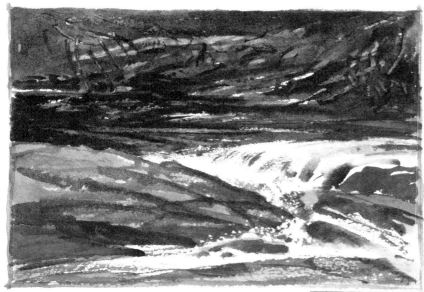

My preliminary sketches

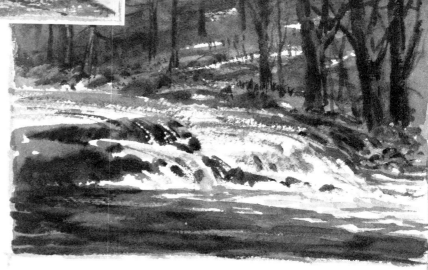

First, I premixed three puddles of greens for the background woods: (1) New gamboge yellow with a dab of cerulean blue for light green; (2) seven or eight brushloads of Winsor blue with two or three of yellow, deepened with a touch of burnt sienna to lend an olive cast; (3) seven or eight brushloads of ultramarine blue with one or two of yellow for a rich blue-green.

By dipping separately into the same pigments used in the palette puddles or dipping into other pigments, then swishing the loaded brush into the edge of any puddle, I can create many harmonious tones on the paper. The larger the massed area to be covered, the more essential it is to create modulations within it by variations in color, value, and temperature. On dampened paper some of the passages will continue to paint themselves; all you have to do is marvel at the beauty of these interminglings and have the good sense to leave them alone.

Sometimes it takes more confidence to stop and watch than to keep on painting. Try doing a woodland background as an exercise on separate paper, and don't forget to label the colors used. Use this exercise to experiment with lifting and scraping techniques to learn how damp the paper should be for best results.

Using my basic puddles, plus the puddles in combinations with additional "swishes," which included burnt sienna or viridian, I painted the background in successive broad strokes in one continuous process (on damp paper), leaving a small irregular light patch.

Using a No. 10 round, I brushed in the directional pattern of the water. The rocks are only indicated for position. In this step, the composition is established as a rhythmic, linear expression except for the background, which is more fully painted. In another watercolor it could be left as is, but I plan to darken it later.

Step 2. The foreground water was painted with wet-blended washes of burnt sienna and raw sienna, cooled with a touch of Winsor blue. The washes swirl over and by the foreground rock, but a few random spots remain white paper and are left that way. Using burnt sienna and ultramarine blue in equal amounts and with additional dabs of each added to the mixture, I painted the middle-section rocks quite fully where they define the edges of the water. These edges are vital and are either wet and blurry or ragged with drybrush strokes. On 300-lb. paper the brush easily drags over the textured surface.

Step 3. The rocks have been painted more fully now with an equal mixture of ultramarine blue and burnt sienna and dabs of brown madder alizarin. Planes were defined with light cobalt blue and crevices with burnt sienna and blue. The white paper left on the top edge of the large rock was tinted with cobalt blue to which a touch of raw sienna was added. The rock formation to the far right was extended.

The upper-level water was painted with the light green mixture, then grayed with a little burnt umber as it came forward and finally washed out into a pale tint. The blue green puddle, with enough water to make a pale tint, plus some tints of raw sienna, was brushed into the white foamy water area.

A green stroke in the center water section was scrubbed out by wetting it with a brush and lifting with tissue blottings. This lightening effect enabled the white water passage to flow into this area with less distraction.

Touches of light green were added to the foreground water. The shape of the partly submerged foreground rock was altered and enriched with color. A combination of blurry and dry edges enhances the effect of water spilling over the rock and rushing by it. Where these edges formed accidentally, I have left them alone, but such decisions are not easy to make.

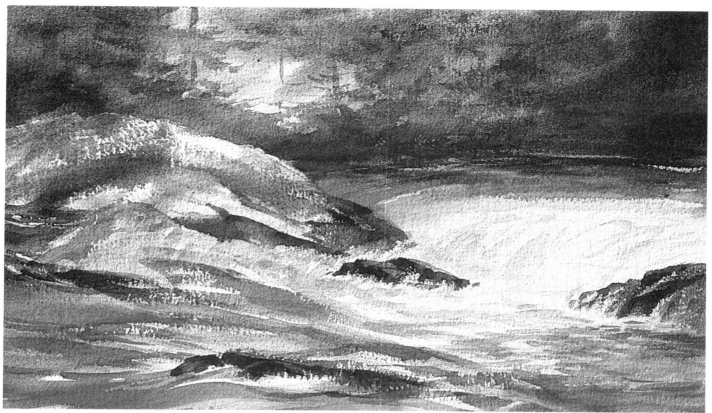

Step 2 Detail

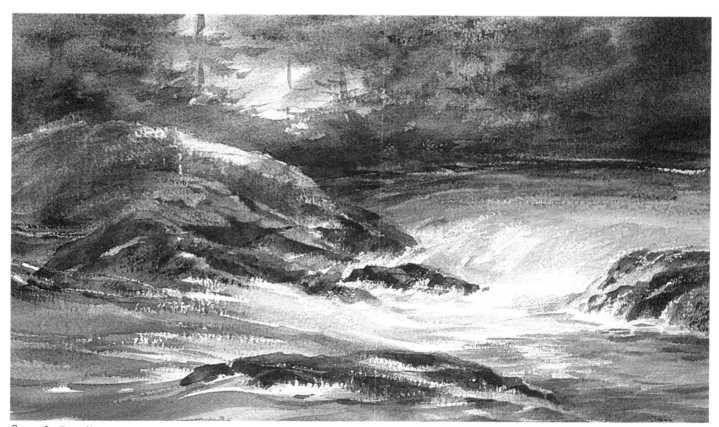

Step 3 Detail

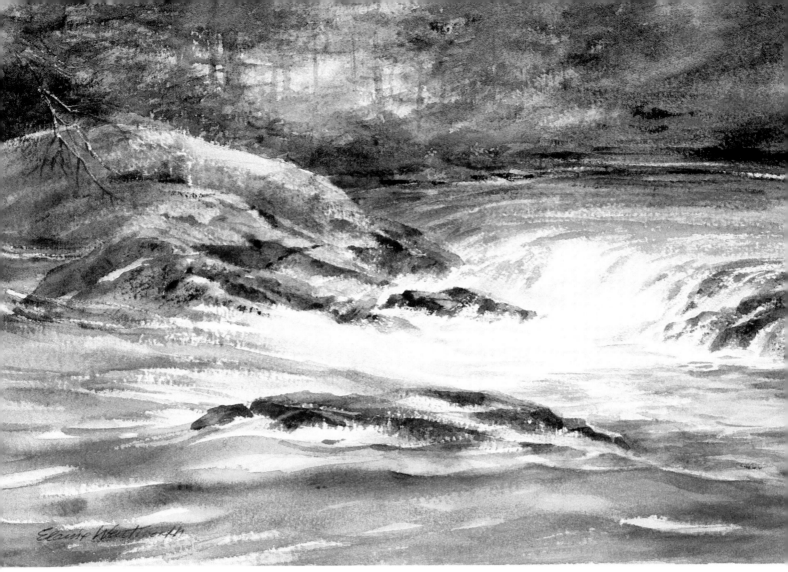

Step 4 **Woodland Stream**
300-lb. medium surface paper

Step 4. The left-side rocks were cooled and darkened on their left planes with cobalt blue. The highlight on top was cooled with a tint of Winsor blue.

The light green in the water was extended forward; a touch of burnt sienna dragged just behind it and flicked into the rapids. A stroke of burnt sienna was added to the far-background water and the shoreline edge at the far right defined with a stroke of Winsor blue.

Evaluation can sometimes take longer than actual painting time. I liked the background as is, but it was not dark enough for my original concept. I decided I should follow my plan, as every other area was painted with this first concept in mind. The scale of the background woods came into larger focus by making a wider tree trunk and some larger brush strokes. The

dry twig over the large rock enhances the space perception.

So that the light patch left in the background would not dominate the lights in the rapids, I cooled it with tints of viridian mingled on the paper with tints of raw sienna. The background on the left side has become more intimate, but on the right it remains a remote, distant place. I like this feeling, so I left the right side alone. I am always searching for a little mystery in a painting. I sense its presence in nature, but painting it is quite another matter.

As I studied the watercolor at this stage, I decided the burnt sienna foreground water was too bright and too active. I lightly brushed it with clear water and gently tissued off some of the pigment. While it was still damp, I brushed on yellow-greens in more tranquil strokes.

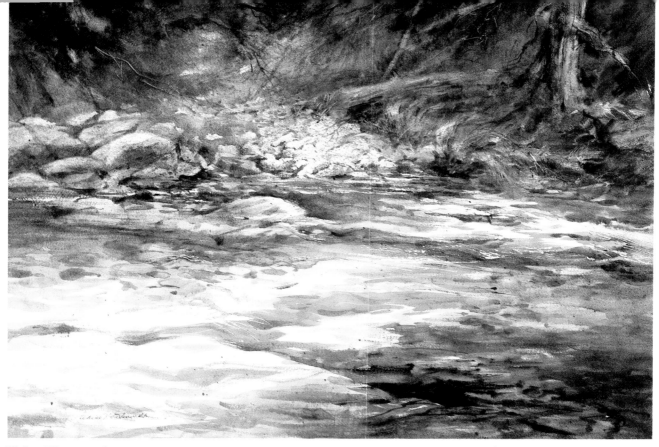

Elaine Wentworth

Forest and Stream
22 × 30 inches, 300-lb. medium surface paper

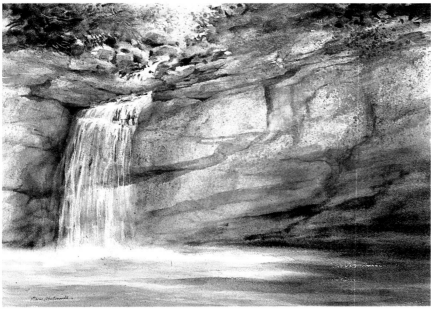

Elaine Wentworth

The Falls at the Emerald Mine
19½ × 27 inches, 140-lb. medium surface paper

Color harmony is similar in these two paintings. Both share dominant, warm earth tones, and spots of hot colors bounce along on the rocks and accent within the deep cool greens. Both have passages with untouched white paper; both have water patterns that range from white paper to new gamboge to dark greens.

The Falls at the Emerald Mine was begun in a workshop evening demonstration after spending the day with my students on the site. I kept most of the greens vivid as a happy reminder of my fascination with this interesting North Carolina setting.

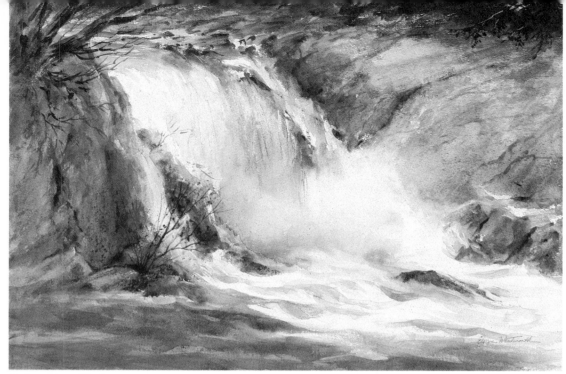

Swimming Hole

Elaine Wentworth

22 × 30 inches, 300-lb. medium surface paper

These two watercolors share a cool-color harmony. The warm colors, unlike the earthy tones on page 91, are also cooled down to red violets glazed with cobalt blue and ultramarine blue.

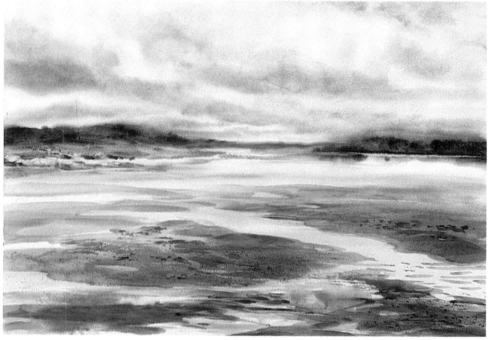

New Beginnings

Elaine Wentworth

15 × 28½ inches, 140-lb. medium surface, Fabriano

In both these paintings there are passages of unpainted white paper. As you can see, in concept they are totally different. Notice here the clear example of clouds receding and appearing smaller in the distance, helping to establish the feeling of space.

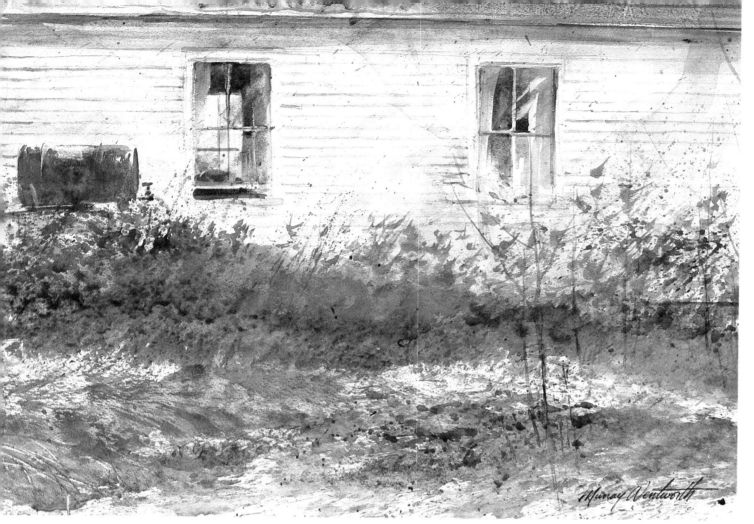

Meeting House
11 × 15 inches, medium surface paper

Meeting House / *Murray Wentworth*

The strong qualities of the summer light are emphasized in this painting, and a subtle balance of darks and lights must be carefully thought out. I tried to capture the intense sunlight across the clapboard sides of the house and the delicate reflective qualities of the two windows as the sun pours over the surface.

Care was taken to keep from overrendering the two windows, as this would have made them too academic and perfect in form. Deliberate restraint must be exercised in capturing the essence of light. Restraint is likewise necessary to achieve a suggestion of details within the windows. In this case, the subtle pinkish curtains in the right window create the feeling of motion and light (see detail) while the left window is more restrained. I tried to capture reality in the simplest terms. The rust tones in the barrel and the warmth in the grasses help achieve pictorial unity and variety across the picture surface.

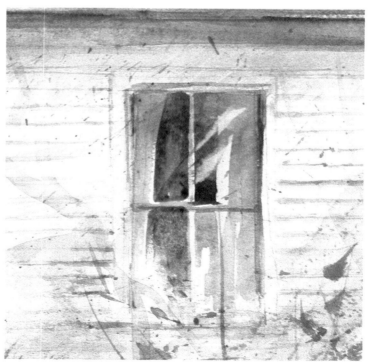

Detail

93

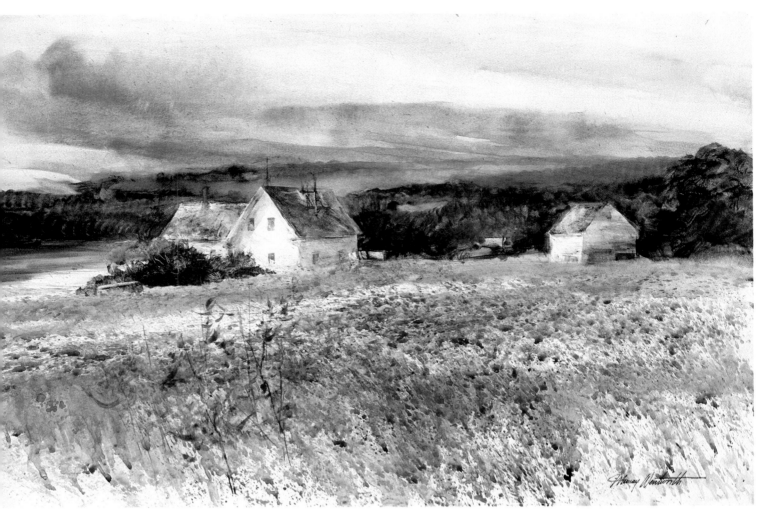

Passing Showers
20 × 30 inches, smooth surface paper

Passing Showers / *Murray Wentworth*

After a morning rainstorm the sky became
extremely dramatic with heavy cloud forms
that raced by in endless patterns throughout
the day. As a result, the light quality was
particularly exciting. The landscape itself
seemed to become part of the shifting,
sweeping motion of the clouds as they
passed over open fields.

This painting was done on location and
developed to a point where it was taken
back to the studio for refinements. The
cloud forms and the distant hills needed
redoing. I washed out most of the clouds
and reworked them into a more satisfying
pattern. What appears to be done quickly
sometimes requires more deliberate
planning. Because the grasses were swaying
in the wind, the field was carefully built up
with spatters of paint to form a rhythm of
dried weeds and suggest the brittleness of
the late summer grass.

Weathered Barn / *Murray Wentworth* →

Step 1. After I made several preliminary
studies, I began the pencil drawing on
smooth paper. A light wash using mostly
yellow ochre and a small amount of cobalt
blue was brushed into the sky area. The
dark tree shape was established next, using
approximately equal mixtures of New
gamboge yellow and Winsor blue grayed
down with a small amount of burnt umber.
A wash of pure raw sienna was used to lay
in the grass area at the right side.

I then mixed a dark mixture of Winsor
blue and burnt umber in about equal
proportions and a small amount of raw
sienna to establish the interior doorway,
pushing the paint around with my finger
while still wet to suggest objects and
reflected lights within the dark doorway.
The use of raw sienna here creates warm
reflected lights within a very dark area.

Using a mixture of a little raw sienna and

Step 1

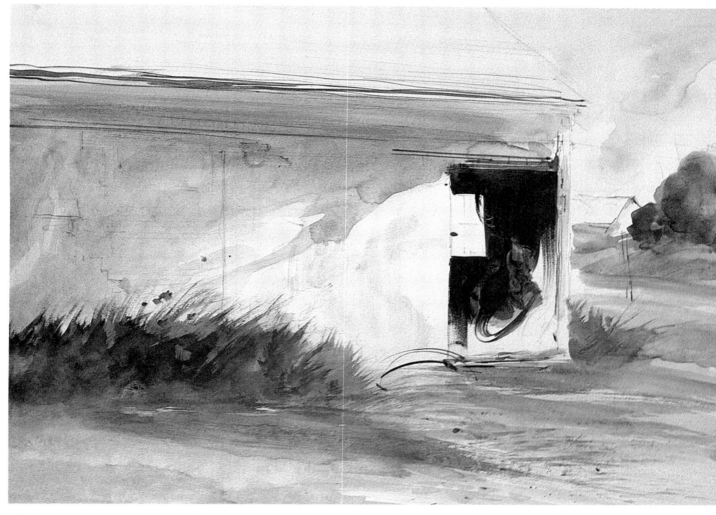

Step 2

ultramarine blue, I began the big shadow area sweeping across the barn. Under the eave of the roofline I used a strong wash of raw sienna to create reflected sunlight, adding a touch of brown madder alizarin for added warmth. The entire side of the shed is silvery gray blues and ochres. The texture was added later. A quick wash of gray green was used to help establish a needed value variety on the large expanse of siding.

Step 2. At this point I added still more shadow tones on the side of the shed, using the same values of ultramarine blue and raw

sienna to keep the warm reflected lights.

Stronger accents were placed on the distant trees at the right. A slightly warm tone was added to the small barn in the distance. A dark grassy area was put next to the open door, and cast shadows were indicated across the ground area. These were kept fairly light in value at first and more brown than green. Using dark reddish greens, I brushed in some dark accents on the grass with my 1-inch chisel brush and also put in the shadows sweeping across the foreground, but left pure paper at the right.

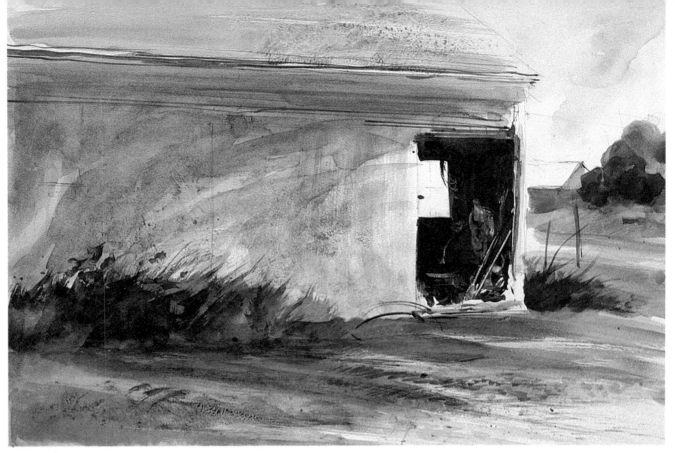

Step 3

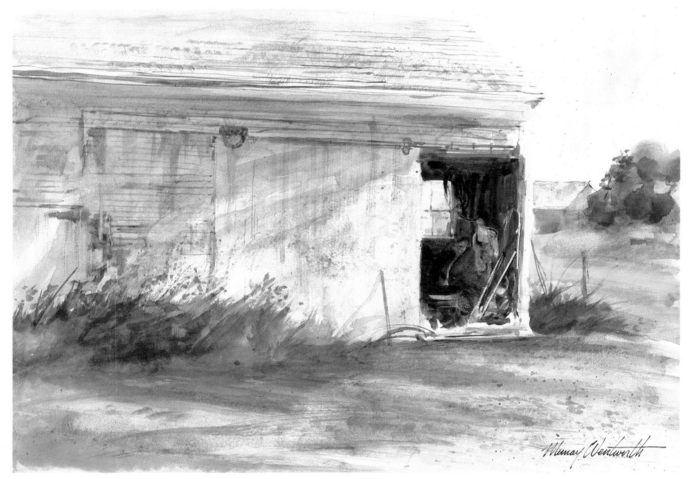

Step 4

Weathered Barn
10¹⁄₂ × 14¹⁄₂ inches, smooth surface paper

Step 3. A light warm wash was placed across the roof area and a little texture suggested by tapping the heel of my hand into the wet wash, leaving lights near the right edge where it meets the sky.

More washes were added across the face of the barn, and a light warm tone placed on the light part of the door. In doing this I was careful not to lose the feeling of strong sunlight while retaining some warm tones in the wood.

The interior doorway was carried further by adding more darks and scraping out the suggestion of objects and tools within the area. This must be kept simple, and the feeling of "air" within the darks must be present. A combination of cools and warms was used here. The diagonal scrapes were done with a razor blade to give the nearest corner a suggestion of light catching some objects at a sharp angle. Using your fingers with wet paint is helpful when you want some interesting patterns within a dark area.

Ground shadows were then developed further, and darks in the tree at the right were deepened.

Step 4. Textures on the roof were developed through light washes and line work to indicate old weathered shingles in sunlight. (Note the lost edge where the sky meets the roof plane.)

The entire side of the barn was completed with various textures. Using a small round brush, I indicated the old door hinges and other details of rust and weathered wood.

Details were added in the grass in front of the barn. A few small leaves were accented against the sunlit areas. I felt that a stick against the door would help if placed at a slight angle in the bright area of the large door.

The interior window was completed, and a little cerulean blue was added in the dark area for color interest and vibration within the dark areas.

The building at the right was painted in dull reds, and the tree was refined a bit. The foreground-area textures were developed by a little more spattering and additional brushwork on the ground shadows.

Village Hillside/ *Elaine Wentworth*

This composition has four levels of landforms with structures serving as light accents in the hillsides. The cloudy sky sets the mood for the color harmony. Passing cloud shadows are wonderful resources for unifying the landscape with enriched values. Since cloud shadows have no stationary source such as those cast by permanent forms, they can be placed with some freedom and imagination.

I penciled in the main elements and drew the houses in correct perspective, then painted them quite loosely. Pale tints of raw sienna and cobalt blue are used for the lights. The design is a composite of what I saw all around me. Creating an interesting light and dark pattern was the major concern. I wanted to capture an overall feeling for the place, a sense of both the expansiveness and the friendliness of this rural setting.

The background hills are rich mixtures of Winsor blue (toned down by adding a little burnt umber or black) and deep greens, made from combining Winsor blue with small amounts of raw sienna or raw umber.

The tidal flats are painted in transparent overlays. The first wash combined minglings of raw sienna and raw umber. Burnt sienna or brown madder alizarin mixed with a small amount of ultramarine blue was then washed on. If the overlaid colors are washed on leaving patches of the first wash, the result will be an interesting combination of broken color. If this final result seems either too warm or too cool, you can wash on a final glaze of either raw umber or burnt sienna (very pale tint) or cobalt blue to cool it down. If you want this final glaze to be very smooth and ensure that it doesn't disturb the previous colors, use a soft Hake brush.

The shore and water merge together in mingled tones except in the middle distance, where a streak of white water has sharp edges on both sides to create a focal area on the right side.

Village Hillside
22 × 30 inches, 300-lb. medium surface paper

Island House
33 × 30 inches, 300-lb. medium surface paper

Island House / *Elaine Wentworth*

The light here is quite subdued, and the mood expressed is peaceful and perhaps a bit melancholy. From our camp on the mainland we have a distant view of this house and the open sweep of field. Just to be there creates for me a sense of being in a familiar yet unknown place, and as a result, my mood is one of exhilaration. The island is deserted now and the only inhabitants are some sheep.

Silhouetted against the sky, the abandoned stone house with its weathered, boarded-up blue windows is the dominant feature. The air is full of motion. To suggest this feeling, I have indicated variations on the values on the house. The light on the front side is left more for the sake of design than to imply sunlight. The sloping rock ledge outcropping is stroked and spattered with the cool colors. Lots of raw sienna is used for the grasses, built up with successive layers of both warm and cooler tones by adding grayed greens. The stone house has basically mixtures of raw sienna, burnt sienna, and ultramarine blue. This is textured with heavy drybrush scuffs of raw and burnt sienna and glazed with cobalt blue in broad strokes. Cerulean and cobalt blues are used for the faded window boards.

Rain Barrel / *Murray Wentworth*

The surface textures of the old weathered barrels are of particular interest to me. Over the years I have painted many similar subjects. The upper background was purposely left white to help emphasize a strong light quality. The main value contrasts and textural emphasis are concentrated on the barrel. Some of the lighter textures were lifted out with water and soft tissues and reworked several times to simplify and change the complex and busy surface.

The light bouncy feeling of the plants and leaves is introduced to offset the more rigid structure of the subject. Such variation goes a long way toward making simple objects interesting and appealing watercolors.

Rain Barrel
15 × 22 inches, 300-lb. smooth surface paper

Deep Spruce
20 × 30 inches, smooth surface paper

Deep Spruce/ *Murray Wentworth*

The complexity of light and shadows in woodland subjects presents an exciting but difficult challenge. The initial excitement for doing this painting was the dancing lights on the old shed and the repeated lights in and around the spruce trees. Dealing with a difficult subject, I made several attempts to capture the play of lights and was not really happy with any of the results. This one seems the best of the lot. The shadows constantly shift, and the whole scene becomes an illusion—now you see it, now you don't.

I believe that once you decide on a design pattern, you should stick to it. Sometimes this causes trouble. Late afternoon, when setting up to begin, most of the side plane of the shed was in open sunlight. In a short time the whole accent rested sharply on the corner area. Soon it completely disappeared.

The initial big dark areas of trees and the large masses of the foreground grasses were established first. Next, I lightly indicated some shadow design on the side wall, preserving the light areas with care.

I worked for about two hours on location, and things began to build and develop. I made moment-to-moment decisions as I went along. Back in the studio, I simplified the background lights by washing out and reworking a section of the trees at the left. Then I put the darks back in, making several revisions in and around the trees, adding details, and moving the light areas slightly for more varied design.

The Headland

Land's End / *Elaine Wentworth*

I've long been familiar with the scene of the lonely house on the point, as indicated in my sketch. But, oddly, I had never ventured over to the ledges on the far side of the light station. It was like discovering a new world, the concept was so different! Everything seemed more remote and lonely—more rugged, too.

On the approach side with mowed grass and pathways you look up at the house from a low eye level and the building is a silhouetted shape against the sky. In painting *Land's End* I focused on the deep crevice which was catching glints of strong light and contrast of values. The house was deemphasized and pushed back by introducing patches of sea fog.

There was an overall quality of light I wanted to capture. Without diminishing the strong value pattern, I gradually added cool tints to the predominantly ochre, pink, and rusty tones of the ledges. Viridian green mixed with raw sienna or raw umber seemed to cool the warm tones yet let their vibrancy glow through the glazing.

The picture was painted on location. I propped my drawing board on a flat ledge and worked on my knees. Later some adjustments were made in a more comfortable position. I kept the painting set up in the studio where I could look at it when passing by. It was weeks before I was finally finished with it and was satisfied with overall tonality.

By contrast, *The Headland* was painted with a more spontaneous approach on a sunny but blustery day. No buildings intrude on nature here; just the focus of churning water splashing against rocks and into the deep crevice. High surface board was used.

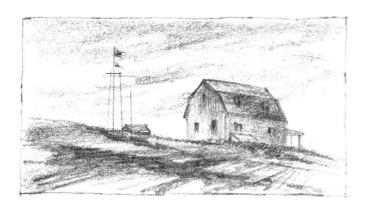

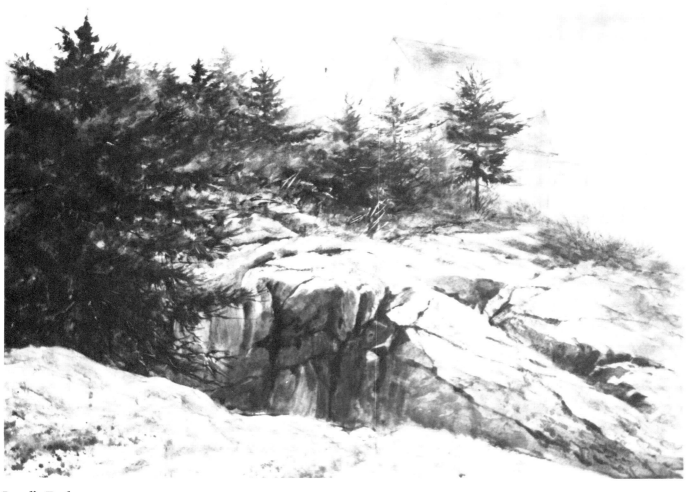

Land's End
22 × 30 inches, medium surface paper

Tree Shadows / *Murray Wentworth*

The strong lights and contrasting darks play an important part in this tree study. The whites of the paper were preserved as the most brilliant play of sunlight. Then I carefully built up the darks and planned the cast shadows cutting across the trunk. Intermediate tones and textures were placed with deliberation so as not to destroy the big patterns and shapes that define the larger forms. The sky was deepened to emphasize the intense light qualities. A few crows were added to bring a little interest to the space, to add more movement, and to create a lively feeling that I wanted to achieve.

Tree Shadows
21 × 16 inches, cold-pressed paper –

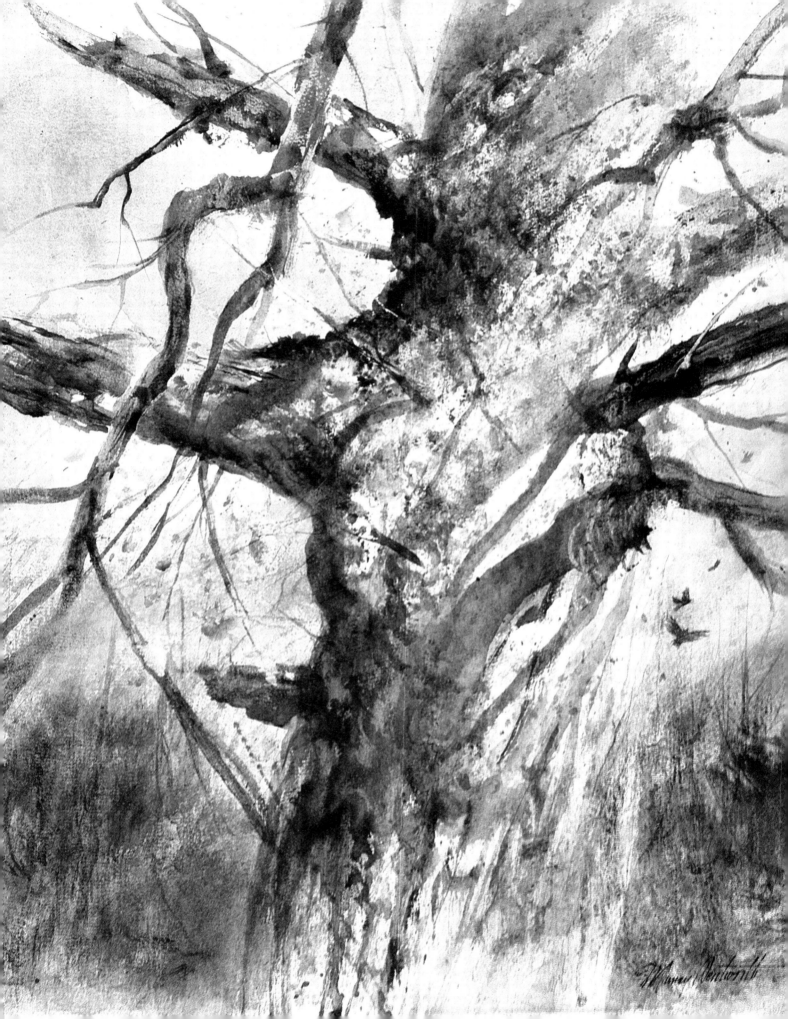

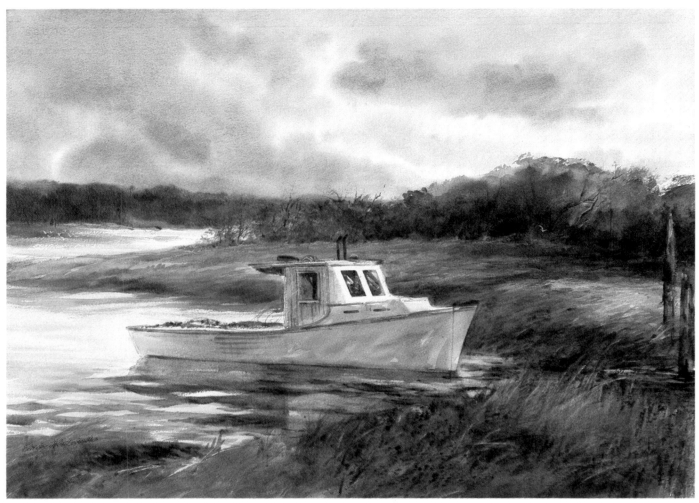

Tranquil Anchorage
22 × 30 inches, 140-lb. medium surface paper

Tranquil Anchorage/ *Elaine Wentworth*

"Every day, paint a sky." Do you think that's an unreasonable suggestion? I read it somewhere, and duly impressed, I tried, but after a few days it rained and other handy excuses intruded. However, the results after even a few days of this discipline were notable. Someday when I get organized, I'll do one every day, for sure!

A low horizon line affords a fine opportunity to make the sky the principal motive in the painting. Even when it is not the major focus, the sky can be a valuable resource in a composition, as its lines may sweep in any desired direction. You can use the sky to help balance, accentuate, or modify other more rigid areas of your picture.

You can look up the names of cloud forms elsewhere. There are many classifications. Whatever type they are, they are subject to aerial perspective. As the sky recedes into distant space toward the horizon line, the forms and colors diminish in intensity, value, and scale.

I like to paint skies that are full of movement and suggest ominous atmospheric conditions. I usually start by dampening the paper and brushing on pale tints of a warm color, which might be cadmium orange, brown madder alizarin,

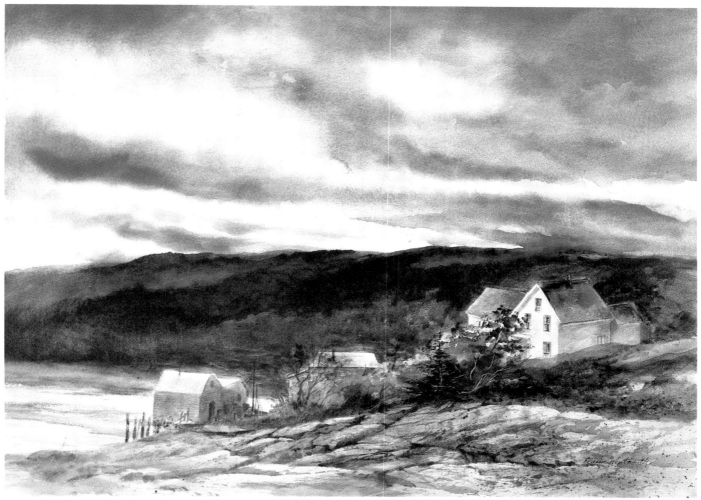

Scudding By
22 × 30 inches, 140-lb. medium surface paper

raw sienna, burnt sienna, or even burnt umber—but remember, very pale tints. This underpainting is concentrated near the horizon—a condition caused by the density of the pollutants in the air near the earth's surface. While the paper is still damp, I brush on whatever cool colors seem called for, often a mixture of ultramarine blue and burnt sienna, diminishing the size of the strokes as I work into the distance. On a clear day cerulean blue is a good choice. Often patches of cerulean show through the darker clouds, which is what is happening in *Scudding By.*

If you want to paint billowing clouds, you have to plan carefully. I know of no safe and sure approach. If you are taut, your fluffy clouds may solidify on you. It is sometimes possible to achieve effective cloud masses by modeling the shadow areas while the paper is very damp, then brushing the color out into clear water and white paper. The final step is to brush the sky color on quickly so that it will blend softly into the wet, almost white paper edges of the clouds. However, it is not necessary to achieve technical virtuosity in order to end up with a splendid painting. A few hard edges and crawly run-backs may even make your skies more lively.

Shed Window
15 × 20 inches, smooth surface paper

Shed Window/ *Murray Wentworth*

Windows as a subject for paintings have fascinated artists for many generations, and they continue to be an intriguing concept to design. While on location at a boatyard that had several old sheds grouped about, I came upon this particular window. The weathered framing and storm sash took my attention. Besides these features, there were two layers of glass—a storm window plus the regular glass—both of which created reflections.

Careful analyzing of values was made to emphasize the transparency of these complex layers of glass (some of the inner panes were broken) yet minimize the interior detail. Through the window I could see an opening on the far side of the shed. The vertical and horizontal shapes were carefully placed to create an interesting pattern against the pure white opening on the other side. Since I was working on the shadow side, there were no cast shadows to enliven the vertical plane of the wall facing me. However, there was a strong overhead light pouring down on the roof which lent definition to the form of the structure. The "lost" edge on the roof helps to accentuate this reflective brightness.

The strongest dark and light value range was concentrated within the window itself and the open space on the far side. Without the subordinate top lighting, the window might have become too much of a tunnel vision. I tried to capture a certain mysterious feeling about looking through and beyond the inside of this old shed.

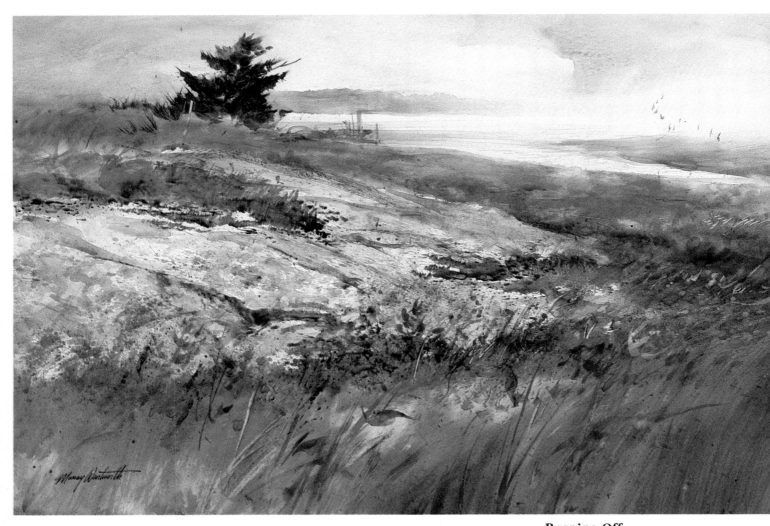

Burning Off
20 × 30 inches, smooth surface paper

My preliminary sketch

Burning Off / *Murray Wentworth*

Over the years I have returned to this small nearby Massachusetts coastal section, and on each visit there is always something new to trigger the emotions. The area has a wealth of material for painting. This proves that you don't have to travel great distances to find exciting new material. The various light changes and times of year always create new visions to keep the painter alert and inspired wherever he may live.

I began the painting on location, carried it to a point of near completion, then brought it back to the studio for analysis and detail refinement, such as the weeds and rock textures, which require special attention and thought. Adding the birds at the right helped suggest some life and movement.

The ledge area has endless possibilities for design. Here the whites of the water are repeated on the surface of the rock shapes. The pine tree establishes a solid dark upright shape which, in this case, stops the eye from leaving the composition at the upper left corner. The design might be made to work without the tree, but I like the way it stabilizes the horizontal movement. The darker cloud at the right echoes the vertical thrust in addition to emphasizing the bright sky near the center.

My initial concept of the scene

Town Line / *Elaine Wentworth*

This was a great day for painting watercolors. The skies were obligingly dramatic, but it did not rain.

The value thumbnail sketch shows the grouping of buildings and includes a wider view of the foreground shoreline. After doing several sketches, I decided to simplify the composition and come in closer on the bridge and the reflections in the water below. The bridge, a long strip of cement, presented a problem because I had to include it in order to paint its reflection in the water. Variations in color and value, the addition of spattered texture helped diminish its bland shape and gave it some life. The house and the surrounding foliage were painted first; from there I worked into both the distance and the foreground.

The quality of light in the sky influenced the color of the foreground water. The overall effect was cool. The greens were mixed, sometimes from Winsor blue, sometimes from ultramarine blue—depending on whether they were to be vibrant or subdued—with raw umber, raw sienna, or new gamboge yellow. Burnt sienna mixed with the blues made lively neutral shades for the heavy skies. Raw umber and blues were mixed for the water reflections.

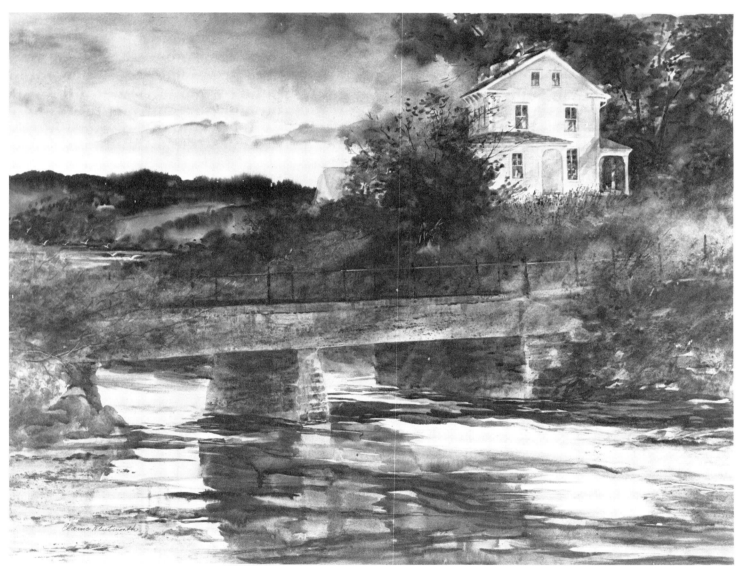

Town Line
22 × 30 inches, medium surface paper

Water Pitcher / *Murray Wentworth*

This small painting was developed in the old kitchen area of the Grange Hall where the watercolor, *Country Kitchen* was painted. These white porcelain pitchers are used for serving the crowds that gather at the grange for various functions. Sunlight streamed in through the window above the old black sink and counter and struck the porcelain surface with a brilliant burst of light.

I began several pencil studies for composition and design decisions, then started the drawing of the pitcher on the smooth paper, allowing the concept to expand and develop from that strong focal point. It began to grow into a larger design with more of the window and cupboards around the sink area worked into the composition. I finally decided it would be more effective, and create a stronger emphasis on the object, to crop it slightly on all sides.

The reflected sunlight was wiped out of the dark tones of the boards behind the pitcher. A damp paper towel was used to remove paint and soften the edges.

Water Pitcher
10¹/₂ × 14 inches, smooth surface paper

Above the River
10 × 14 inches, smooth surface paper

Above the River / *Murray Wentworth*

We have driven by this interesting house
many times on the river road at Turkey
Cove. Recently I began several paintings of
it. It's surprising how many times you see a
subject and never seem to get at it. This
small painting may be used as a preliminary
for a larger work in the future.

I created more space than there was by
pushing back the structure and leaving out
several trees. The large sweeping field
above the cove lent itself to the feeling of
openness and simplicity. Several
compositions can surely be developed
around this house and river area.

Getting to know the people who live in
the areas you paint helps the artist. It makes
for more relaxed working conditions when
treading on other people's properties. Elaine
and I have gotten to know several places
well, and the owners have been kind
enough to give us permission to work
uninterruptedly anytime we wish.

The Tidal Zone

. . . I have always paid great attention to natural forms, such as bones, shells and pebbles, etc. Sometimes, for several years running I have been to the same part of the seashore—but each year a new shape of pebble has caught my eye, which the year before, although it was there in hundred, I never saw. . . .

—*Henry Moore*

Elaine Wentworth

The sea, the eternal moderator of the earth and the seasons, is ever changing. At times our seashore can be so calm and serene we almost forget how fiercely violent the wind and the waves can become. Yet most of the time in our area the ocean lays a gentle, temperate hand on the extremes of summer and winter. In our tidal zone the climate seems to be neutralized into a more even seasonal ebb and flow, making a setting that constantly beckons the landscape painter.

Murray and I love to linger on the wet rocks as the tides rises, listening to the rush of foam. The spray wets our face and fills

120

the little crevices at our feet. I scoop up the salty water and splash it on my face and arms. It is for me the perfume of life, and nourishment for my soul.

High water, low water, rushing waves, stagnant pools, crusty ridges, seaweed, and the pearly tones of fog and mist create a pulse of life that never ceases to generate the urge to paint. Once exposed to the scene in whatever season, I must gather my gear, prop my board on a flat rock, and set up my palette. Such moments of joy and magic are the source of inspiration. For me it is what being an artist is all about.

The health of the eye seems to demand a horizon. We are never tired so long as we can see far enough.

—Ralph Waldo Emerson

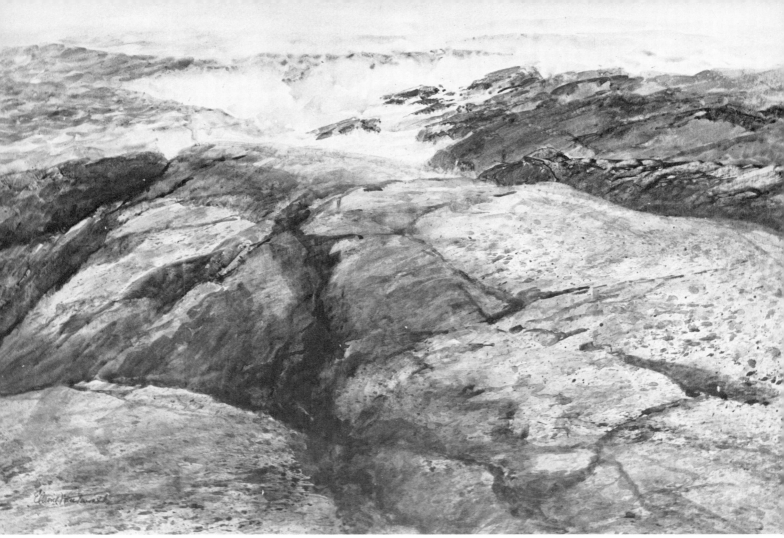

Surging Point
20 × 30 inches, smooth surface board

Surging Point / *Elaine Wentworth*

The granite ledges plunging into the sea
appear to remain intact, but eventually they
are altered at this meeting place of elements
of earth and water. It is, finally, the sea that
dominates. Thoughts on this balance
become part of the intuitive feelings that
influence my paintings. It is not my hope to
master a formula for painting ocean themes;
mystery and the unexpected are as vital to
me as the recurrent and predictable.

In this watercolor I'm trying to show the
power of the backwash as the white water is
sucked down the sloping rocks to meet the
incoming waves. The top third of the
composition depicts this, and the ocean's
edge is the main focus. The foamy white
water has delicate hues of yellow, pale
green, and blue-grays. Leading the eye to
this area of activity are the directional
thrusts of the ledges and crevices.
Contrasting with the cool colors of the sea
are subtle warm tones of crusty
lichen-and-barnacle-covered granite, painted
with raw sienna and burnt sienna. The
crevices also have spots of hot colors.
Overall, however, these warm tones are
low-keyed to project the mood of an
unsettled day when a storm at sea is
approaching the land. Smooth paper allowed
for a variety of textural effects including
built-up spatter.

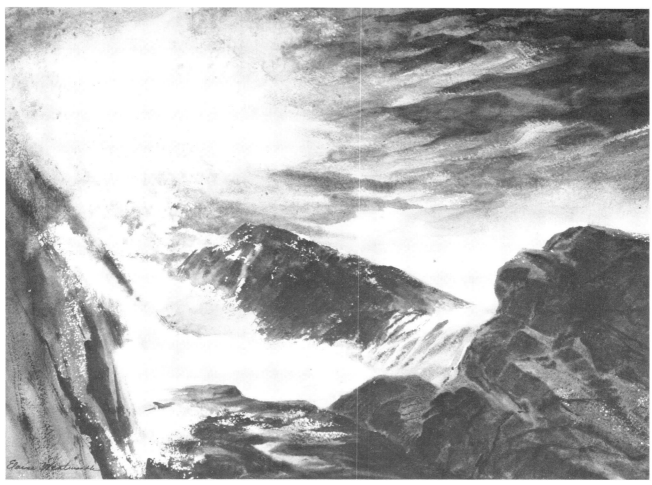

Impact
17×23 inches, 140-lb. medium surface paper

Impact / *Elaine Wentworth*

This is one of five watercolors painted on location in sequence, during the bypass of a hurricane. Like *Surging Point,* no horizon is shown, but this time we are looking down on the scene, and the center of interest is held to a limited area. The diagram plots the rhythmic directional movement. Whether your own eye enters at the sweep of ocean that ends with the slam of spray on the ledge wall or from the bottom ledges inward is not that important. What *is* vital here is that the activity of foaming water swirling around the rocks is not diluted with secondary areas of interest.

With a brush and light color I indicated the rock pattern, then built it up with additional strokes, some wet, finally dry enough to drag. The water was indicated before the rocks were finished so I could judge the relationship of their values.

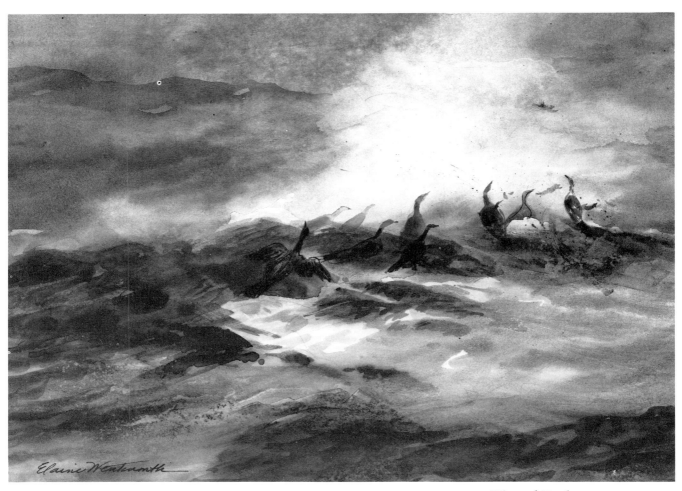

Winged Realm
9½ × 13 inches, medium surface paper

Winged Realm / *Elaine Wentworth*

I like to keep a watchful eye on these offshore ledges as tides and weather change them. Sighting through field glasses, I can observe what birds are coming and going out there in the marine world. I love to imagine being there, encircled by a running sea.

On medium smooth paper taped down, then dampened with a sponge, the first strokes skim the surface and blend into soft washes. These middle-value colors—blue-greens with raw sienna showing here and there—depict the horizontal plane of the water. These colors were brushed out into almost clear water for the misty spray area and the foreground passage of churning foam.

At the left are a few little shapes of white paper with hard edges; adjacent are the darkest rock strokes. The diagonal thrust of the major ledge is painted with both warm and cool colors and both hard and soft edges. Darker blue-greens were overpainted in the immediate foreground and also in the background to indicate the slanted plane of the waves. The foreground light passage is greenish-yellow with touches of blue, painted over darker strokes that indicate a submerged ledge. Because these first strokes remain intact, there is a sensation of being able to see below the water's surface. The cormorants vary from dark blue umbers to shadowy shapes obscured by spray.

Rock Bed
20×30 inches, smooth surface board

Rock Bed / *Elaine Wentworth*

These gently contoured forms invite one to stretch out while contemplating what to paint. While lying there, I noted how the sun sparkled on the narrow strip of sand and stones between the ledges. The basic forms are similar to *Winged Realm.* Instead of the open sky I saw in the background, I preferred to paint a dark contrast of dense spruce boughs with a few lifted-out light accents to carry the dark pattern across the entire length without monotony.

Taking advantage of the slippery paper, I brushed on and let drip raw sienna, burnt sienna, and a variety of blues; then watched them run together to form settled puddles and rivulets over the ledge area. When the area was dry, I "found" my configurations of rock textures by enhancing what was already there. This process takes patience, as you must continually step back and evaluate what is needed and when *more* is *too much.* Within the sandy strip I found small stones and some interesting beach debris. With a small brush and the same colors I added these textures using the fairly opaque manganese blue for bright accents. Spatter, built up slowly with various hues and values, was used in almost all areas to enrich this watercolor.

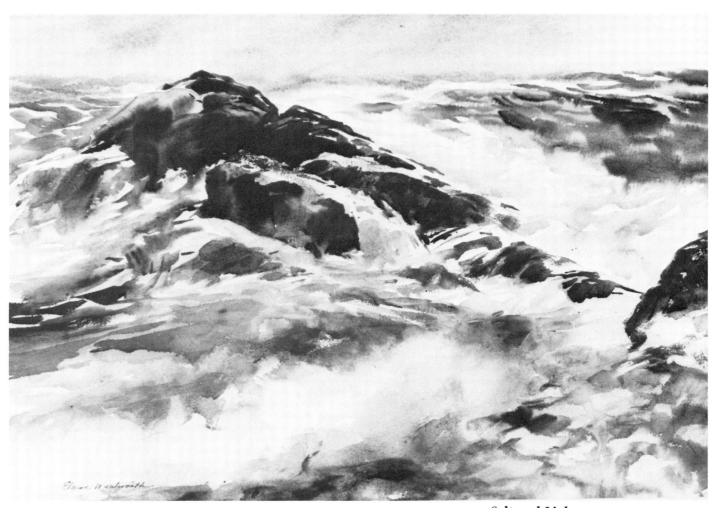

Salt and Light
22 × 30 inches, 300-lb. medium surface paper

Salt and Light / *Elaine Wentworth*

Salt and Light was painted on a bright day when the sunlight bounced off wet rocks and filled every atom of the scene with pulsating motion. The tide was high, and the turbulent seas were spilling white water into every crevice. Cautiously, I lowered myself and my gear down the rocks until I found a vantage point that enabled me to be almost within the swirling motion and yet safe from its danger.

This very transparent watercolor relies on the strength of the first strokes and washes. The ledges are wet mingled washes plus dry strokes of burnt umber, burnt sienna, raw sienna, and ultramarine blue. The water tones are mixed from Winsor blue and new gamboge yellow with additions of cerulean and ultramarine blue. Faint warm tones in the foreground are tints of burnt sienna. The unpainted areas of white paper have both hard and soft edges, which resulted when the surrounding washes were first put down. Too much refining would destroy the sparkle of this watercolor.

The excitement of painting in such a spot helps me to work vigorously to completion and leave the pondering for later. By the time I was done, I was as wet with spray as the rocks. Later, I slightly darkened the sky, but basically, it remains a totally spontaneous expression of a wonderful day by and in the sea.

Detail

Step 1

Demonstration

Sea and Rocks / *Elaine Wentworth*

Step 1. Once I determine the directional thrust of the opposing forces of land and sea, I rough in the composition lightly with a brush. In this downward view of the scene the light from the unseen sky reflects off the surface of the water, pale blue green in color. This basic mixture is composed of approximately equal amounts of ultramarine blue and raw sienna with dabs of one or the other added here and there as I paint. Onto sponge-dampened paper I brush on these pale subdued colors and in one continuous process paint small choppy waves receding into the distance. The large wave is brightened with a bit of yellow; this wash bleeds unchecked into the damp paper. The ledges are only indicated for position.

Step 2. The major tilt of the foreground ledge was indicated in the initial lay-in, but the details evolve from each successive stroke. The positive-negative pattern of white water flowing between the crevices becomes more clear. A ledge at the left was added. A pale green wash in the right foreground water creates an edge against the sloping ledge, which is white paper for now. Pale raw sienna with just a dab of green to cool it slightly was brushed over the middle-area ledge. (The green originates from the same ultramarine and raw sienna

mixture used in the water.) It is now apparent what the composition is all about.

Step 3. In the middle-area ledge the original lay-in brush stroke has remained visible but now becomes broken up into levels of sloping ledge. Each stroke of a half-inch chisel brush creates a plane that can be modified or further defined by the next stroke. On top I was careful to leave light first washes visible. Colors used were olive green, made from ultramarine blue mixed with slightly more than half of raw sienna with a few flicks of burnt sienna added to it, plus these last two colors separately.

Additional strokes on the foreground ledge brought the water passages into stronger focus. Notice in the lower right foreground I have lifted out dark details that seemed distracting and changed the direction of the strokes. A little spatter was added.

Where the middle ledge meets the large white passage, I brushed on pale blue green strokes indicating the eventual flow of the spilling-in surf. (The color is a mixture of ultramarine with a little less than half of raw sienna.) Pale strokes have now identified the surface of the foreground sloping rock where it meets the water's edge.

Step 2

Step 3

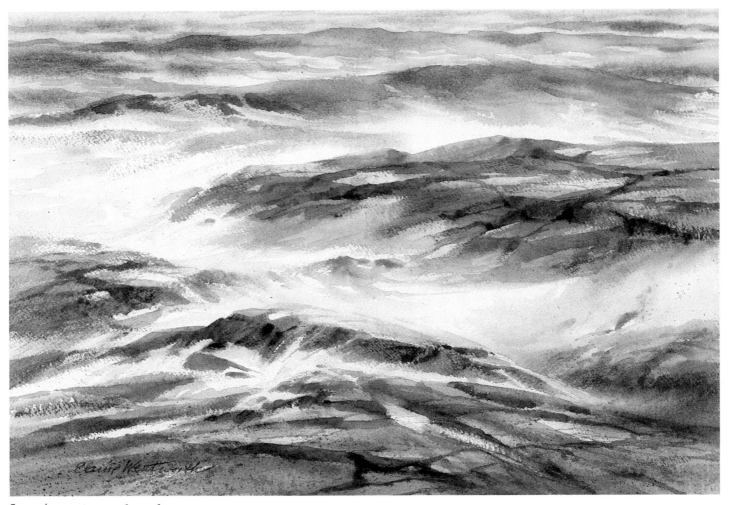

Step 4 **Sea and Rocks**
140-lb. medium surface paper

Step 4. The large white passage was brought to completion starting at the far right and working back to the open sea. First, I dampened the entire area with a small natural sponge. Using pale raw sienna and touches of Winsor blue and a bit of ultramarine blue, I dropped in dabs and let them mingle. While the area was somewhat damp I enriched the far right lower rock, but kept it vague, half hidden by spray. Flicks of burnt sienna enriched with a little cadmium orange indicate flying kelp in the spray. A light spatter on the lower right rocks hits the spray, which agitates the surface in a subtle way. The idea is to achieve a sense of liveliness rather than placid rigidity. That side completed seemed to suggest the direction of the next group

of wet strokes. A stroke that had been there since Step 1 now demanded to be made into a submerged rock. The swirls of churned-up water at the far left are pale strokes of raw sienna.

The sloping ledge in the center foreground needed to be accented with stronger darks where it faces us, and the top surface was identified just a little more clearly with pale ultramarine blue mixed with just a touch of raw sienna. The large wave was strengthened, and the outer ledge brought into focus. A few light small strokes were added into the water, and the next wave deepened with just a touch of blue-green. The fuzzy edge of the middle ledge was deepened into a more substantial form.

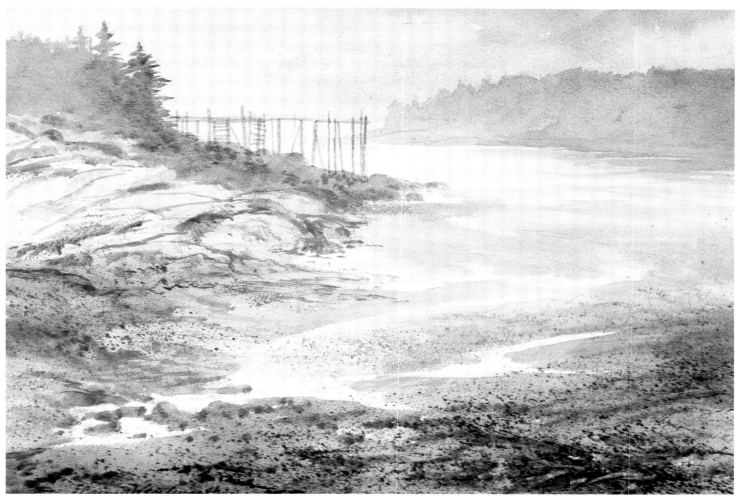

Pearly Time
8¹/₂ × 12¹/₄ inches, 140-lb. medium surface paper

Pearly Time / *Elaine Wentworth*

This favorite little watercolor was painted inside the camp after we were rained out when painting the same subject on location. In the dense atmosphere of fog all the objects become grayer and less defined until all details disappear and only pale silhouettes are visible. It is surprising how crisp the edges of these pale shapes appear. Mists can be painted with wet and blurry edges, but fogged-in silhouettes that are not being diffused by mists need dry edges. The colors in fog can change from yellow-gray to pink or lavender-gray; from green to blue-gray. Look intently into the fog to find these subtle but beautiful variations. *Pearly Time* has a combination of blurred to dry edges. It is an atmospheric impression of a much-loved place. For me it represents what painting is all about.

Sea Watch
10 × 14 inches, 140-lb. medium surface paper

Sea Watch / *Elaine Wentworth*

Have you ever noticed how people will perilously pick their way over rocks and crevices to reach the outermost vantage point for watching the sea? The lure of the sea compels us to the very edge of its danger and fascination. This is a windy day with choppy whitecaps cresting far out to sea. The colors indicate a summer sea with a blue haze in the windy atmosphere.

Some paintings owe their pictorial coherence much more to an inherent, overall quality of color than to a strong value pattern. You notice this in the work of the French Impressionists with their unrestricted brushwork. The strength of this little ocean study, with its fairly robust brushwork, is more in the overall blue tonality than in the value pattern. You will notice a similarity in composition to *Surging Point* on page 122, but the color harmony and atmosphere of the day are entirely different.

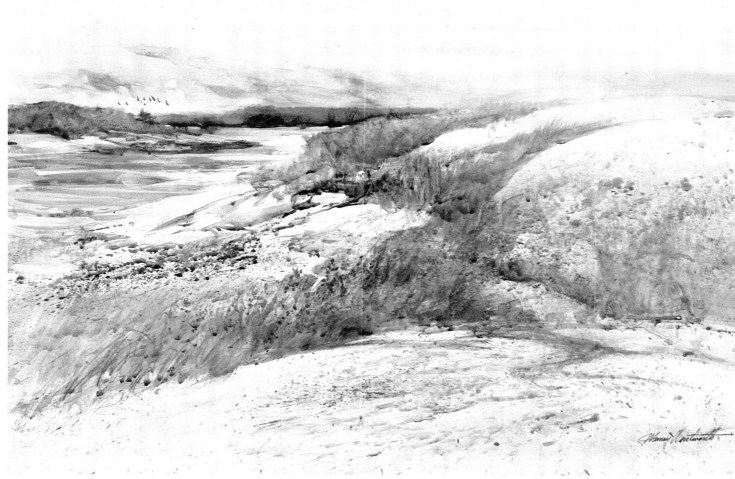

Island Light
20 × 30 inches, smooth surface paper

Island Light / *Murray Wentworth*

On a bright calm day we had an
opportunity to paint on a small nearby
island off the coast of Maine. We were taken
to the island in a small boat and left to work
for several hours. The boat was to return
and pick us up in the late afternoon.

The setting was so inspiring that at first
we didn't know what to settle in on to
paint. The dynamic simplicity of the shapes
was overwhelming, but after walking around
the entire island, I settled on what seemed
to best capture the essence of the place.
The light was bright and directly overhead;
the colors were intense yellows and blues.

I did not stop to plan any rough studies;
instead I just began drawing these big
shapes and working out the composition as
the painting progressed. Some changes were
made later, such as adding the birds on the
left, giving more depth of color to the sky,
and refining some of the water patterns. But
basically, this painting is spontaneous and
the refinements minor. The whites of the
paper were left to intensify the bright
summer sunlight.

> *When you shall have acquired some proficiency*
> *in foreground material, your next step*
> *should be the study of atmosphere—the*
> *power which defines and measures space.*
>
> *—John Ruskin, Letters on Landscape Painting, 1855*

Demonstration

Boathouse and Dory / *Murray Wentworth*

Step 1. After the preliminary study was made, in which I decided I had a workable composition, I began to lay out the design in pencil on cold-pressed paper. At this point I paid particular attention to the placement of the structure and changing the old sunlit log into a white dory to repeat the white in the building.

I washed in the sky using a light tone of yellow ochre and allowing it to dry. Then I brushed in a wash using mostly ultramarine blue and small amounts of burnt umber over the previously dried ochre tones. A very small amount of cerulean blue was added for brightness. The ochre gave a warmth to the area.

The darks of the trees were put in next to establish the darkest accents against the building, using an almost equal amount of burnt umber and Winsor blue and a small amount of black. (Black is used to tone down the intensity of Winsor blue, although this is not always necessary. If you use it, do so sparingly.)

A light wash of new gamboge yellow with a small amount of Winsor blue was washed into the middle-ground area, creating a pale greenish cast.

The bushes next to the white building were placed using about equal mixtures of ultramarine blue and burnt sienna with a little burnt umber.

A very light mixture of ultramarine blue plus a small amount of burnt umber and brown madder alizarin was drybrushed next to the boat to establish some directional brushwork for the foreground area.

Step 2. Using a mixture of mostly ultramarine blue and a small amount of burnt umber, I established the distant land which now defines the water area. The same dark mixtures I used for the bushes were used to complete the large dark tree plus the trees at the left. The darks in the door were added at this time.

A wash of cobalt with a bit of ultramarine blue was painted across the roof of the shed, drybrushing across the area to leave some white paper for added lights.

Preliminary Study

Step 1 and Step 2

Step 3

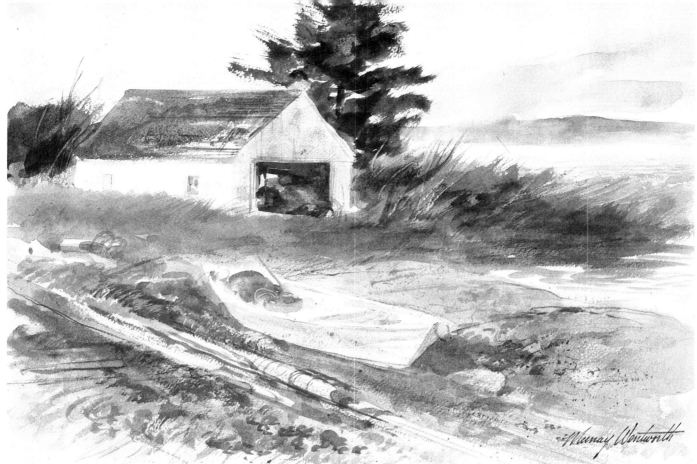

Step 4

Boathouse and Dory
cold-pressed paper

To achieve variation, the grass was strengthened from left to right and from the greenish tones to the warm reddish tones. At this time a few razor-blade scratches were added to the darks to suggest some of the grasses catching the light.

A pale wash of grayed blue and a little burnt sienna was used to begin the form of the large rock next to the boat, and dark drybrushing at the left suggests the textures in the sand and mud.

Step 3. I added more darks in the sky and darkened the values in the distant land area at the same time, using a gray blue wash which also indicated the water surface. Here the brush stroke was dragged across quite dry, leaving some white paper for brilliant lights over the surface of the water.

The shadow side of the shed was defined with ultramarine blue and a bit of ochre, followed by drybrushing for textural variation. A little sienna was used to give warmth inside the door opening, with some bright spots of cerulean blue to add local-color interest and liven up those darks.

Dark water reflections were placed at the edge of the grassy area at the right. The values were deepened across the middle grasses over to the darks around the tree. More washes were built up on the rock ledge, and surface texture was added.

Darks were applied in the left, leaving some white paper to suggest the feeling of old bleached wood and also to allow some sparkling whites near the white dory.

Step 4. The background and middle areas appeared to work rather well, so I concentrated mostly on the completion of the foreground. Surface textures around the dory were built up, and the forms of the old logs were developed further. Shadow detail placed in the white dory gave form to the boat, while dropping in darks representing fishermen's gear helped balance a dark and light pattern.

Darker shadows were added behind the dory and up into the rocks.

Where the heavy grass bank meets the water's edge, I felt it needed deeper values, so I darkened the edge where water and grass meet.

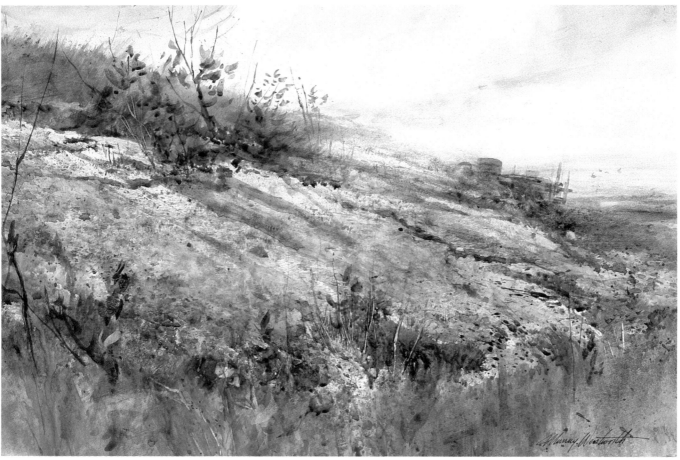

Blue Ledges
15 × 22 inches, smooth surface paper

Blue Ledges / *Murray Wentworth*

This painting was done at the same location as *Burning Off* on page 112.

As previously mentioned, this area offers many possibilities for painting. In this one I used the ledge shapes as a major design factor and subordinated the background. The darks of the bushes are balanced with a small dark accent of a rusty barrel and an old pier—these also stop the eye as it moves downward to the right on the diagonal shape.

The smoky mist was brought out by wiping out the tones with a damp tissue until reaching the white paper surface, almost lifting the paper surface itself by constant scrubbing.

I was careful to preserve those important lights on top of the ledge under the grass area. The close balance of values within the rocks, grass, and bushes was especially important in order to retain an overall simplicity and not break up the design with too many lights. I feel this to be one of my most successful attempts at this difficult subject.

Oil Drum
20×30 inches, smooth surface board

Oil Drum / *Murray Wentworth*

The bright, intense colors found in this subject were challenging to paint. The salt air and water cause metal objects to take on brilliant rust tones. The use of burnt sienna and cadmium red together, over a first wash of raw sienna, brought out the intense rusts and textures. Cools and warms are evident here as the cool blues on top of the barrel merge into the hot colors.

The log shape extends from extreme left to far right, and particular attention was given to variations in textures, values, and colors from one side to the other.

Otherwise, this form would have become monotonous.

The foreground whites were left against a highly-textured surface to give a feeling of strong but hazy sunlight.

I washed in light silvery, yellowish blue-grays in the background to give depth to a shallow space. Note that the lights of the background feed in subtly with the top of the barrel. This ties in the background and creates an overall continuity with the lights in the painting.

Out of Service / *Murray Wentworth*

The impact in this painting depends largely
on the strong abstract shapes and
contrasting value pattern.

I began it on location on a rather gray day
where the values were the dominant factor.
The general colors were low-key—
predominantly umbers and blues.

The heavy textures of rock and seaweed
were a challenge to capture. At times I
worked with the paper almost vertical,
allowing washes to run down and create
their own patterns and textures.

I recall mixing a wash of burnt umber and
Winsor blue and throwing it in the area of
the far right rocks. It happened to fall just
right to form the darks and lights I wanted.
The drips were left just as they settled onto
the paper. In truth, this was quite a
spontaneous painting. Some time was taken
to work in and around the old logs cleanly
and to balance the upright shapes with the
large overall mass. Washes of ultramarine
blue were used on the lights of the top logs,
and raw umber and blackish-umbers were
used for the rich darks.

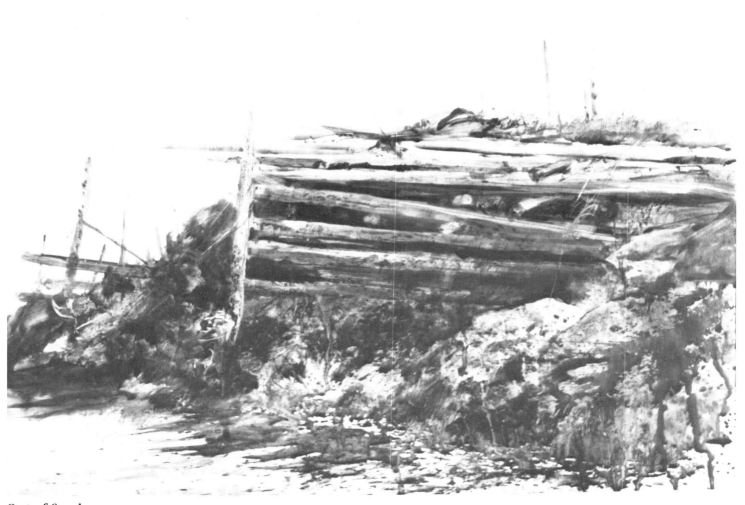

Out of Service
20 × 30 inches, smooth surface paper

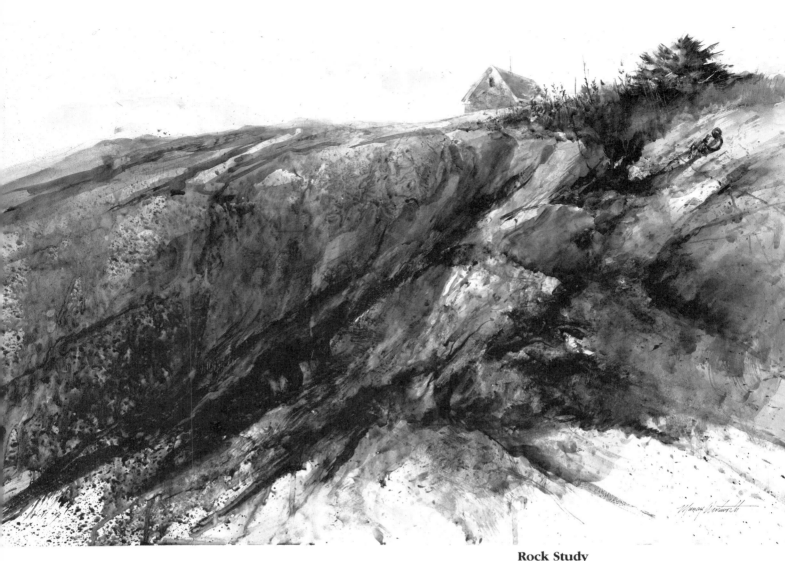

Rock Study
20×30 inches, smooth surface paper

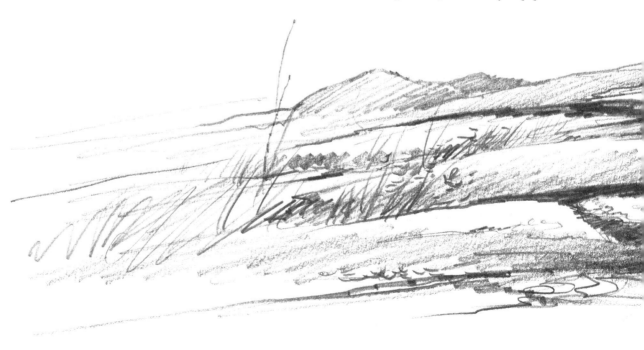

Rock Study / *Murray Wentworth*

This began as an isolated study of an interesting rock ledge, but as it progressed I gradually added the trees and a hint of the building to establish scale and a sense of place.

The smooth-surface paper I used has excellent characteristics for the kinds of effects I wanted. The paint slides and crawls along the surface, which works to advantage for rock formations. A razor blade can remove dark washes and bring out interesting textures, planes, and shapes. I also used my fingers to create various textures.

This study deals with working into shadows, where lots of tonal and color variations are found, yet it must be kept simple. It's quite easy to break up those shapes into shadow and thereby lose the big light and dark form.

Rocks and ledges take on different characteristics of shapes, colors, and textures, and I've found many variations across all of New England, or even in one small area. They are a great challenge, and over the years I've learned to simplify and to look for the essentials in the large overall patterns of color and values.

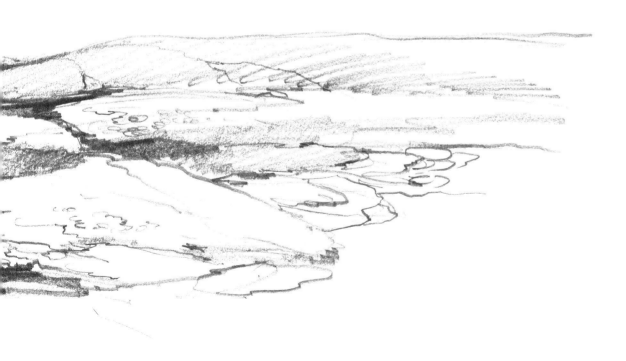

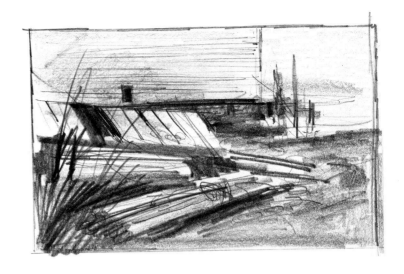

Head of the Cove / *Murray Wentworth*

The strong contrasting value pattern is what excited me about this scene. Obviously, the placement of the lights and darks is most important in creating an interesting composition. Here the strong geometric forms are relieved by the soft descriptive textures of grass at the left and in the elliptical shapes in the distant land area in the water.

The day was slightly overcast, and the sharpness of light seemed quite strong on the surfaces as they are accented against dark seaweed and mud. When the seawater rises, it creates a completely new design that changes the darks into wet reflections.

The diagram shows the simple directional thrusts of the shapes and the small square of open space at the right seems to anchor the movements and hold the viewer within the design.

Loosely handled washes help break up and soften the light surfaces and create a moving, flowing rhythm against otherwise static shapes. The finely scraped-out lines also help to tie the large masses together and create unity.

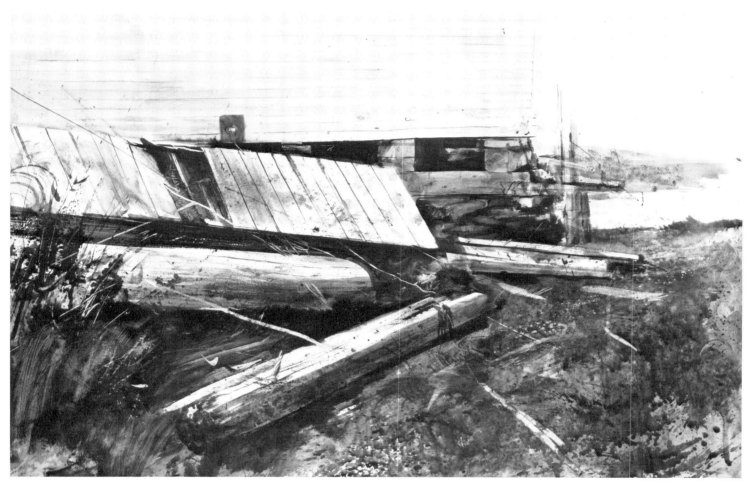

Head of the Cove
20 × 30 inches, 140-lb. medium surface paper

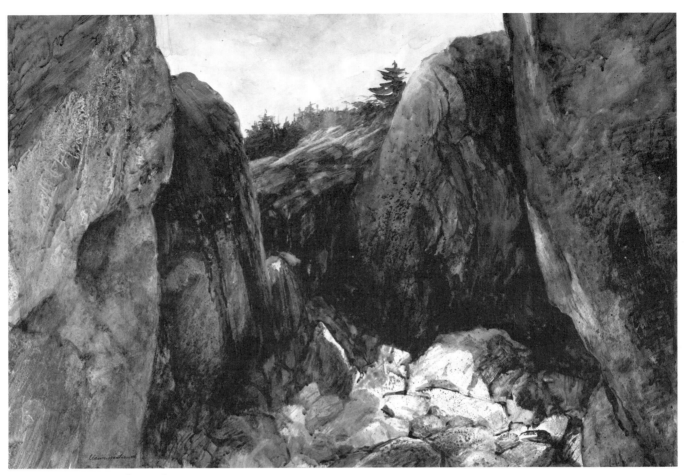

Between the Tides
20 × 30 inches, smooth surface paper

Between the Tides / *Elaine Wentworth*

At low tide I maneuvered myself and all my gear down to the bottom of a deep ravine and set up with my back to the open sea. A shaft of sunlight bounced down the wedged rocks and glanced across the sea-level stones. An endless range of design possibilities exists in this small, cramped space. As usual, I wanted to do it all! The wet rocks glistened with an intense light green. The sunlit bottom passage called for yellow with spots of cerulean blue and adjacent spots of burnt sienna. Sunlit stones are best indicated with an impressionistic approach. This means concentrated observation, then selectively emphasizing an edge here and there, accented with bright

shadows under and next to some of the shapes. In a later version of this subject painted in the studio, I glazed raw umber over the sunlit rocks and achieved the effect of looking beneath the surface of the incoming tide.

You can see that this concept combines a close-up shallow space with a rapidly receding perspective that ends in deep space. Incidentally, I became so engrossed here that the changing tide surprised me with a wave that washed right over my ankles and set me to dismantling my easel and getting everything high and dry as quickly as possible.

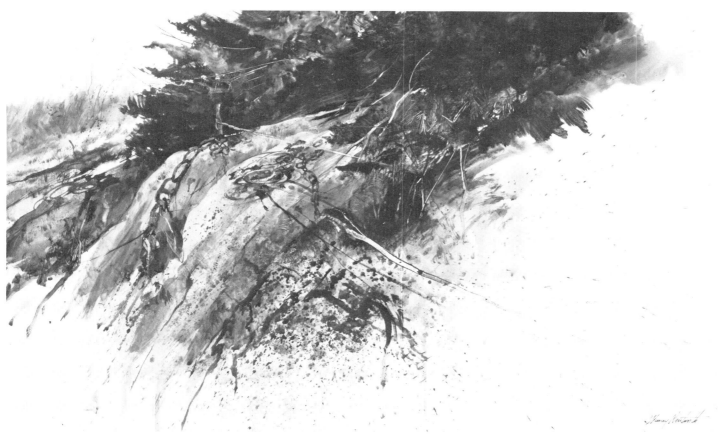

Boat Chains
20 × 30 inches, smooth surface paper

Detail

Boat Chains / *Murray Wentworth*

Old rusty chains such as these are frequently found around the coastal areas. I'm intrigued by them, and they have been a source of many of my paintings. Their size and colors vary, but always there is evidence of the constant battering they take from the unrelenting power of the elements.

I set up at low tide and worked directly on a smooth surface paper. The rock mass had soft pinks, silvery blues, and yellows against the rich, blackish umber blues of the trees and seaweed.

The planes on the two diagonal rock forms were kept simple to emphasize the focal area of the chain links. Scratching of lights was done with the tip of the brush handle in a spontaneous, seemingly unplanned manner. The line scrape-outs that go from left to right were added to give opposition to the strong diagonal that dominates the design.

The drips and runs were left from the first washes to give a kind of casual immediacy to the study.

Back Wash / *Elaine Wentworth*

One of my favorite places to sketch is a horizontal ledge that reminds me of an amphitheater, surrounded as it is by the angle of a vertical ledge. At low tide the crevices are filled with pools of still water containing colorful marine life. As the tide rises, this stage turns dramatically active with surf pounding in and spilling away again, adding a new dimension to the scene.

Setting up my easel at a safe vantage point and with a definite idea in mind, I was immediately confronted with decisions. The large mass of the vertical ledge dominated the area like a frontal plane or façade view, yet the focus of interest has to be the

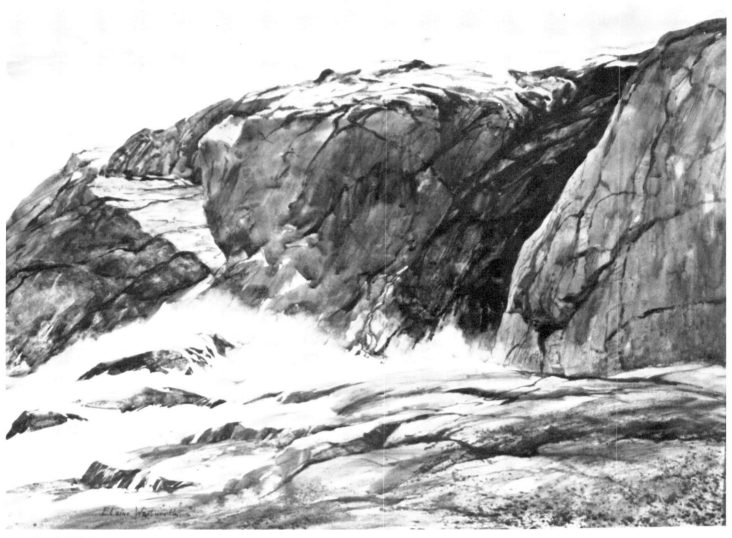

Back Wash
22 × 30 inches, medium surface paper

elusive power of the sea as it ebbs and flows at the ledge's base. Obviously, this area must have the strongest value and color contrasts. To accomplish this, I used the contrast of white paper flicked with tints of ochres and blue-green, accented with darks. This makes the lower left passage the center of interest. The sea behind the ledge was painted in the soft modulated colors with brush strokes that diminished in scale to keep the feeling of distance.

Working into the shadow side of a vertical plane is an opportunity to build up transparent layers of wash. My first washes

on the ledge were warm: raw sienna, burnt sienna, and burnt umber—tints of color washed on freely and allowed to mingle and dry together. This can be done on either dry or sponge-dampened paper. Using a large brush, one or two inches wide, you can cover dry paper swiftly with wet washes. Succeeding layers go cooler using ultramarine blue and cobalt blue, with the first washes of warm colors showing through here and there. The goal is to maintain transparency in this shadow plane so that it does not become so heavy you can't work back into it when dry.

Tide Pool / *Elaine Wentworth*

Sitting on the flat ledge looking across the tide pool and up to the top of the deep crevice, I was enchanted with the way the spruce forest encroached on the very edge and also fell away into a misty distance. At this close range it would be too much for a camera to take in with one shot. But by choosing a vertical format and by adjusting proportion and scale, I could pull it all together into one composition.

For about three hours I worked in the bright sunlight establishing light- and middle range values, building up transparent layers slowly. On the shadow plane a glaze of raw umber over the first washes (yellow ochre, pale burnt sienna, a little ultramarine blue) created a luminous glow, which I astutely left alone. At that stage, fatigue set in, so I took the work back to camp to contemplate before I ruined it with reckless overpainting.

The next day, in the same sunlit hours, I returned to work again. I also did separate pencil studies of the wealth of details; this helped in being selective in adding the dark values and accents. I kept the shadow plane uncluttered because the transparent brush strokes in themselves created a texture. In the top triangular shadow area I lifted out a few lights to indicate glints of sunlight. The lightest passages are almost white paper with a few plastic card scrapes made on the damp tones. I also added some lightly colored spatter. The tide pool has strokes of pure burnt sienna and raw sienna slashed with the plastic card scrapes.

A dynamic subject like this never goes stale. Once I tried it in moonlight . . . and there are more aspects that are yet to be tried.

One of my preliminary sketches

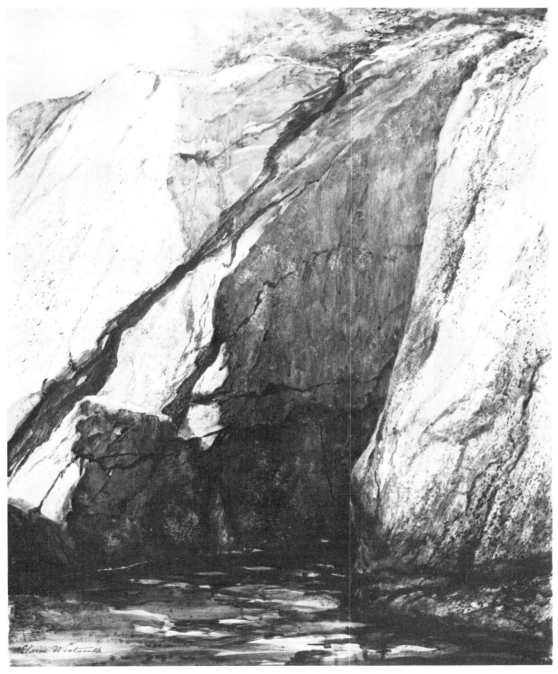

Tide Pool
30×20 inches, medium surface paper

The White Punt / *Elaine Wentworth*

While sketching an old bleached log I discovered on a clamshell-strewn beach, I turned my head and noticed how sun and shadows played upon a white punt balanced on top of another old log. Immediately, I decided my original picture concept could wait for another time. I was intrigued by the little boat, and I wanted to paint the lovely ochres and blues caused by the fleeting angle of the sun.

I determined that the two objects, boat and log, which opposed each other at a diagonal, should be combined in a single design. All surrounding space—foreground beach, middle and far distance—slants gradually downward to the sea. Conceptually, this seemed important. Dark pines in the background might lend a strong contrast in direction and value. Such a composition would be similar to *Frozen Lace* (page 68), and it would be easy to design, but I really wanted to conquer the compositional problem of horizontal planes by using close values throughout.

Color, more than value, makes the middle and far distance fall into place here. The

The White Punt
22 × 30 inches, 140-lb. medium surface paper

field is basically golden, but there are variations of both warm and cool that help make it recede into the background hills. The area is rather narrow to create the illusion of considerable depth. It has to go back immediately or it will appear to ride on top of the punt. The long strip of background hills was painted with variations of blues (ultramarine for warm tones, Winsor for cool tones, and cobalt for glazes that embrace both). One direct wash in that long horizontal band would have been monotonous. To avoid this, I varied the

color, value, and edges (hard to soft) from side to side as well as along the length of both dominant forms.

The foreground beach locks into the main design unit with its own white paper highlights and combinations of dragged brush strokes plus textural jabs, scrapes, and spatter. A light glaze of cobalt and brown madder alizarin gives the effect of wet sand next to the dry, brittle areas. Chains encircling the log create foreground attention and slow down the diagonal thrust.

The North Side
22 × 30 inches, smooth surface paper

The North Side / *Murray Wentworth*

The old Seacoast Lobster Company building
is one of the oldest structures in the Port
Clyde area of Maine. It has attracted many
artists to its weathered and simple charm.
Its massive presence is unavoidable as it sits
on a rise overlooking the harbor.

The dark masses working against the light
structure emphasize the warmth of sunlight.
The geometric shapes are contrasted by the
natural forms of trees and bushes.

The scrubbed look was obtained by taking
a damp 1-inch flat bristle brush and pushing
it (using the side edge) into the dark wet
grass area. This action also lifted out some
desired light areas. The distribution of darks
and lights in the grassy area is essential for
creating a variety of visual interest.

The Harvesting Earth

Nothing Gold Can Stay
—Robert Frost

Autumn Fragment / *Murray Wentworth*

I t's always surprising, the unexpected things you can discover right in your own backyard. All you have to do is keep your eyes open. One day I stepped into a wooded area adjacent to our house and noticed several old stumps surrounded by the beautifully colored fallen leaves of autumn. I drew the composition on the spot, giving particular attention to the placement of the birch stumps. I planned for a vignette shape but did not begin painting outdoors at first.

The painting was begun in the studio; then I went back to the spot for some details of texture and tones on the bark of the tree itself and the leaves. Then I again retreated to the studio, away from the confusion of the woods.

I feel this is one of my most successful vignettes, showing very active, almost furious brushwork, working against a rather careful focal area of the light play on the stump. The white paper feeds into the lost edge of the tree, thus creating and heightening the brilliant light effect. The colors are warm browns and yellows against silvery grays in the tree tones.

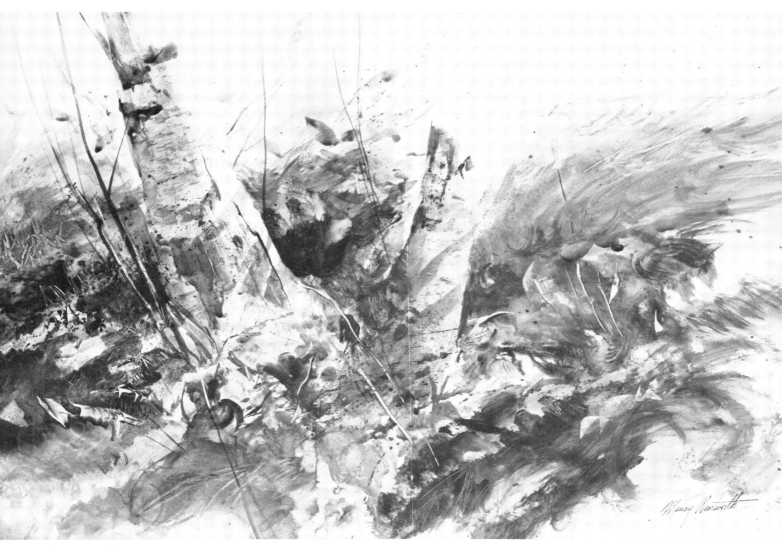

Autumn Fragment
20 × 30 inches, medium surface paper

These are my initial pencil sketches.

Airing Out / *Murray Wentworth*

I began this painting as a slightly longer shape but later cropped it to give more emphasis to the open door. The tones on the outer barn are soft reds, contrasted by the rich darks inside the door. This design could have worked either way, but I decided it was better to restrict the outer edges and allow more concentration on the door.

Variations of texture on the sides help to relieve monotony of so much of the same color and value. By adding the circular shape of an old harness strap, I created a little interest in the stark wall. I varied the spatial organization by using the open window to push beyond the middle ground, thus gaining a greater feeling of depth for an otherwise rather flat painting.

I started the painting on a workshop as a demonstration and carried it only to a point where the open door was formed. Several months later through sketches and refinements I brought it to a finished state.

The textural quality of the foreground hay was scratched out with the back of the brush handle. The old grain box inside the door was highlighted by long scrapes with the razor blade. Instead of painting *around* objects and shapes, sometimes it works better to remove darks with a knife or blade. Often this procedure supplies a more interesting effect.

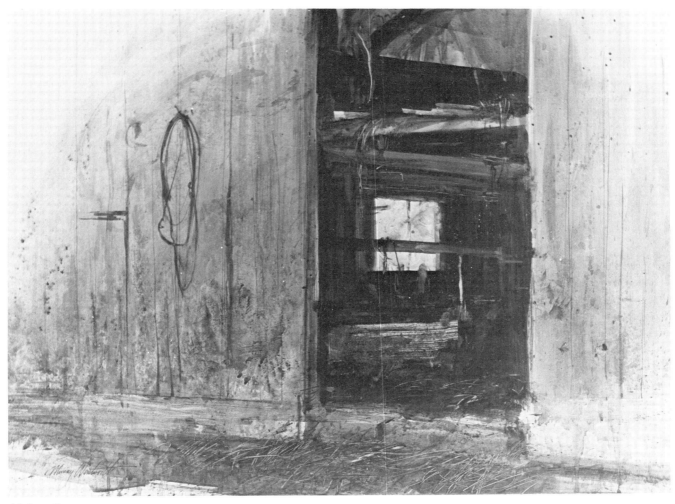

Airing Out
19×23 inches, smooth surface paper

Detail

Sudden Light / *Murray Wentworth*

This painting was begun on location as the late sun began to glance sharply over the ledges. The impact of dark trees above the face of the rock was striking. The silvery gray and yellow rock mass of the ledge played against the black-bluish pine grove.

Actually, it was a small section of ledge that attracted me to do this scene. The immediate abstract pattern of this frontal view was emphasized to heighten the strength of the design. I reduced the crevices in the rock face to their simplest form and concentrated on the small shapes at the right to accentuate the sunlit area. The diagonal shadows help define the form and create a shaft of light across the rock face.

The dark trees were kept very simple with a few light openings for variation and relief. The face of the ledge has been scrubbed with paper towels and scraped a little with a razor blade. Some surface textures were applied sparingly by spattering paint.

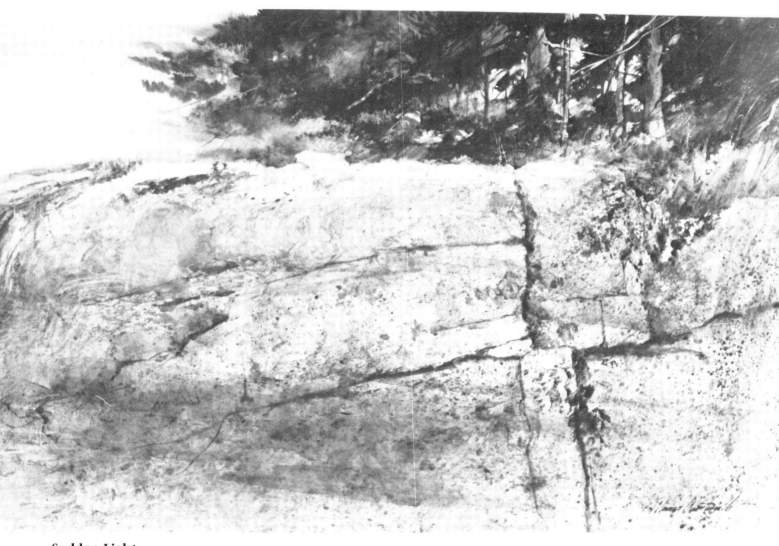

Sudden Light
20 × 30 inches, smooth surface paper

Step 1

Demonstration

Stone Wall / *Murray Wentworth*

Step 1. After developing several rough studies for composition plans, I began the pencil drawing on smooth paper. Using burnt umber and ultramarine blue in about equal proportions and a small amount of burnt sienna, I brushed in some middle values on the stone wall, adding a dark accent in places to get the general feeling of the forms of the rocks. Then the dark upright tree shape was begun using burnt umber and Winsor blue in equal amounts, to get some values stated quickly. A light wash of raw sienna and a very small amount of ultramarine blue was brushed on the top of the hill to develop the shape against the sky area.

Notice that the darks in the wall area are very irregular where the wall will meet against the soft grasses. A few scrapes up into the wall help define the feeling that the rocks are nestled into a grassy terrain and not resting on top of it. Scraping and lifting out of weeds and grass can come later on. A No. 9 round brush and a 1-inch flat bristle were combined for the wall and tree.

Step 2. The tree shapes are now strengthened and defined by using an equal mixture of Winsor blue and burnt umber. A small amount of raw sienna was brushed into this wash and added the feeling of very dull greens. A round No. 8 was used to drybrush the tree forms on the edges.

The back fields were washed in with more ochre and siennas and carried to the top edge of the stone wall, leaving the lights on the rocks until later. Bushes at the right were added.

The stones were carried further by an additional mixture of about equal proportions of ultramarine blue and burnt umber plus a small amount of brown madder alizarin. This established intermediate values.

A little texture was quickly suggested on the rocks at the right by using the side of my hand and stamping it over the light surface. Walls must have uneven and interesting shapes, so care must be given to get an irregular pattern. It is easy to end up with a pile of coal or a row of cannonballs!

Using a 1-inch bristle brush, I brushed in some greenish browns with raw sienna and a little Winsor blue to begin the grassy area. For variations of greens and tans I also mixed new gamboge yellow (adding small amounts of ultramarine blue and burnt sienna) with a little brown madder alizarin.

Step 3. The sweep of clouds was strengthened to enhance the feeling of depth and strong directional pull.

The treeline on the hill was darkened, and the grassy field was developed in more of the same brownish greens and reds. Using ultramarine blue, a small amount of burnt umber, and a bit of burnt sienna, I established the dark values of the bushes at the right side. Several little scratches were made to pick up light textures of weeds and leaves.

The wall is now almost fully stated, and the darks and lights are beginning to read across, defining the entire wall area. Any additional lights that may be needed within the darks can be done by dampening the area and wiping or scraping out new shapes or by making adjustments in various rock forms. Warm tones of siennas were then washed into parts of the darks on the stones for warm reflected lights; otherwise, the whole area could become too dark and cold in color. By repeating the warm tones of the grasses in the stone wall, a total color harmony becomes evident.

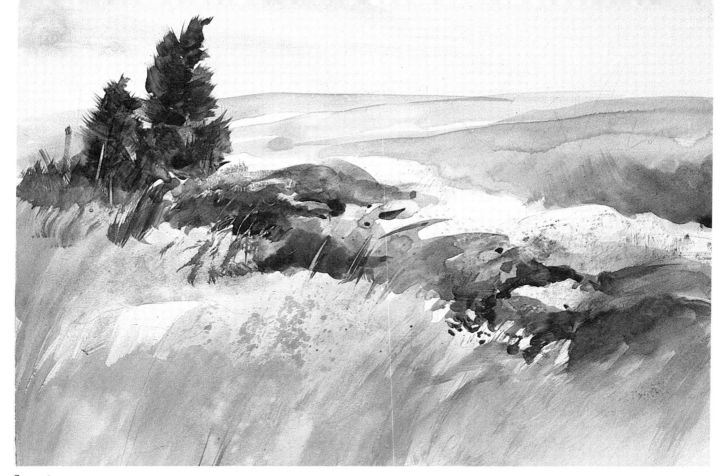

Step 2

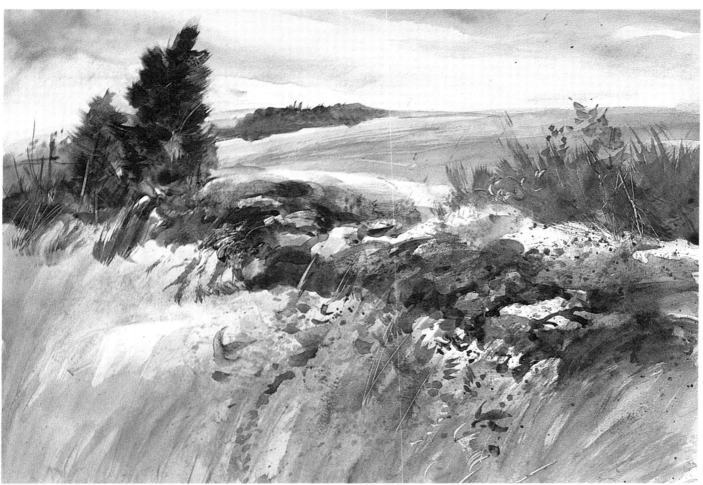

Step 3

161

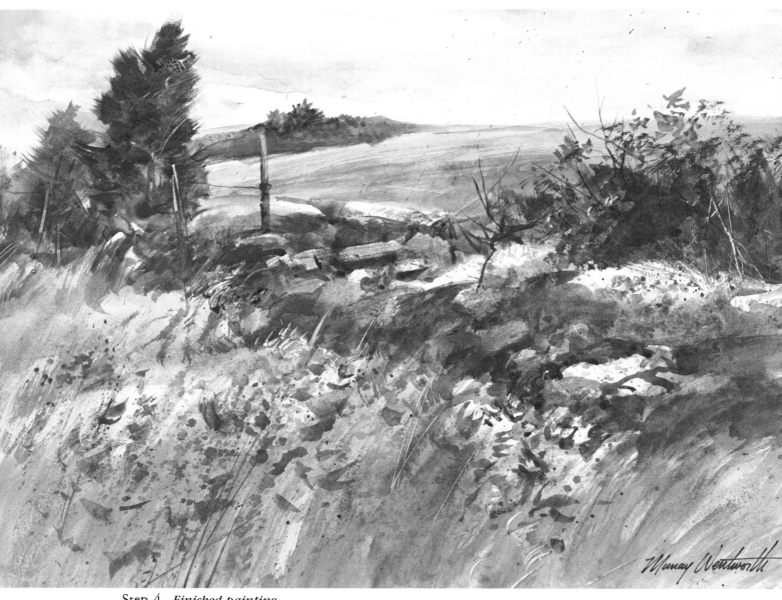

Step 4 *Finished painting*

Step 4. The trees on the back hill were defined by adding a little more brushwork on the hill where it meets the top of the wall. The bushes at the right were pulled together and descriptive texture and a few details added. A few more accents were put in around the wall, and textures were spattered into the light surface of the rocks.

Flowers and weeds were placed in the foreground grass area. Care was taken to group them in an interesting pattern, as it is easy to overdo texture and wind up with a grouping that is much too busy. To suggest a feeling of ferns and leaves, brush strokes

were added up against the wall. I purposely saved the pure unpainted paper in this area. (A little opaque white could also be effective in this case.)

The fence post was added at the right of the tree, which I feel helps break up the strong sweeping back hill and creates an area for the eye to focus on. Note that only one post was used, carefully distanced from the edge of the tree and cutting up into the background. Any more uprights across the top of the wall would have destroyed the space and simplicity of the hill and wall.

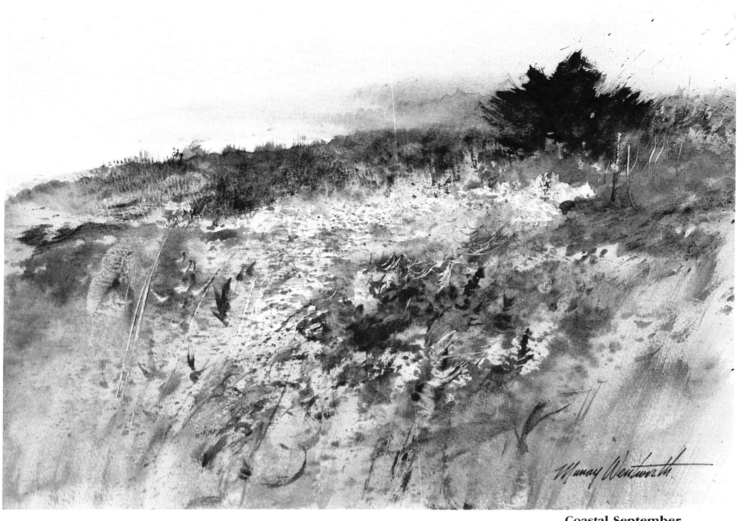

Coastal September
11 × 15 inches, cold-pressed paper

Coastal September / *Murray Wentworth*

This small painting was done on location after completing a large watercolor on the same subject. The design here is altered slightly. The grasses are the dominant part of the painting, supported by the white gleaming light on the distant water. The fields along the coastline are particularly beautiful as the season changes into fall.

Light washes were spattered in the middle distance, and the whites of the paper were preserved to create a bright passage of textures. To emphasize the strong light, variations and sharp edges were used where the grass meets the water. This area is anchored in place by the large dark tree on the right. The sky and distant land area were kept as simple as possible using subtle shifts of cool and warm colors.

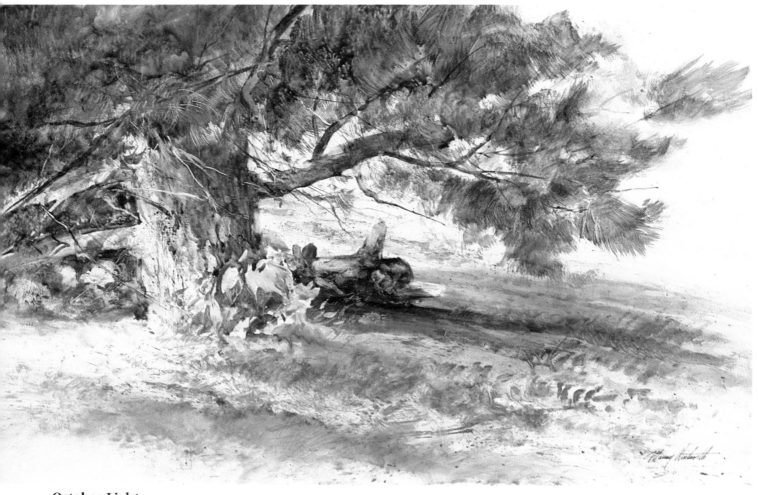

October Light
20 × 30 inches, smooth surface paper

October Light / *Murray Wentworth*

Each fall a strong, raking autumn light plays across our large pine tree and presents exciting contrasts of color and value patterns. After a preliminary color rough, the finished painting was begun outdoors and completed in the studio. Catching the brilliance of light at the right moment becomes the most important part of the entire theme as shadows and light quality rapidly change.

Color sketch about one-third of original size.

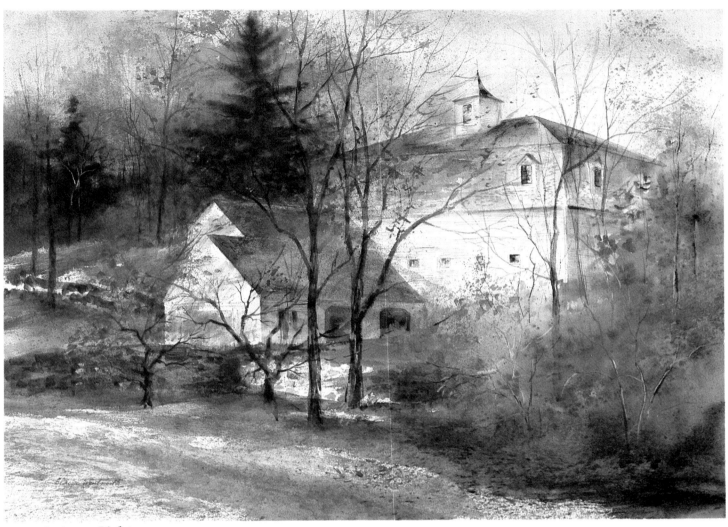

Autumn Light
20 × 20 inches, 300-lb. medium surface paper

Autumn Light / *Elaine Wentworth*

Before you can grasp its wonder, the high-key brilliance of fall fades into lingering shades of rust and burnished ochres. The red, yellow, and orange background hues quickly become washed in a red-violet haze. In summertime midday is usually a hopeless time to set up an easel in direct sunlight, but in autumn, even at midday, the shadows seem to streak across the fields creating strong value contrasts. This is not so much a painting of an old barn, although this property is a historical landmark in Norwell, Massachusetts, as it is a celebration of the season of the year. Color is the fundamental element here. The structure was more complicated than I depicted it, but the

emphasis is on the low, golden sunlight, which mellows and unifies the contrasting forms and colors.

The foreground was painted in several overlays of color, from first washes of raw sienna, followed by variations of green and shadows of blue green. Spattering enriched the surface. The richly modulated colors on the right were wet-blended and also left to intermingle on the sponge-dampened area. Except for a little spattering, it is devoid of foliage detail. The light side of the building is tinted with raw sienna. The palette included New gamboge yellow, raw sienna, burnt sienna, brown madder alizarin, and ultramarine blue.

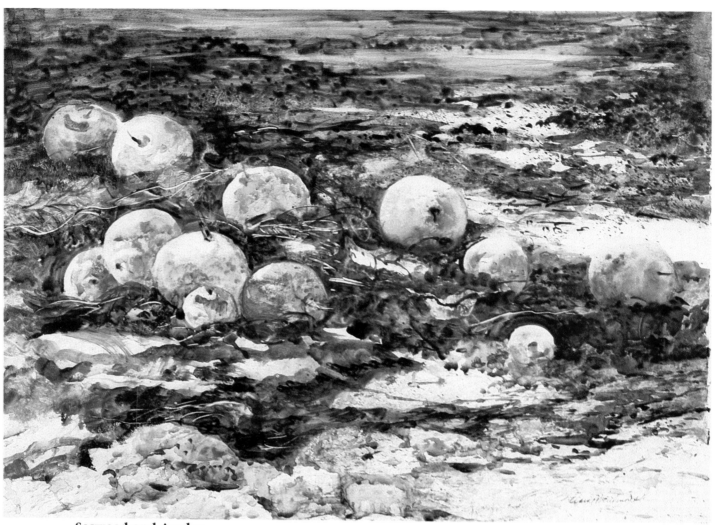

Seaweed and Apples
14 × 18½ inches, high surface paper

Seaweed and Apples / *Elaine Wentworth*

Go for a walk, keep your eyes peeled for an inviting spot, settle yourself down on the ground, and look around you. With a few pivots of your head you may find enough painting material to keep you busy for hours.

One autumn day on Clark Island I did just that. It wasn't until I had finished color sketches of seaside goldenrod and driftwood that I noticed that my feet were kicking into a colorful arrangement of rotting apples poking through the seaweed. Looking back over my shoulder, I realized I was sitting in

the shade of a small apple tree whose branches extended beyond the edge of the field onto the stony shoreline.

No tree branch identifies the subject in this watercolor; the vivid forms and patterns must speak for themselves—bright circular notes of high color arranged within strips of deep red-violets and textured accents of cerulean blue, raw sienna, and burnt sienna. Scratching with fingernails into the smooth surface paper is an effective way to indicate tiny twigs that catch the light.

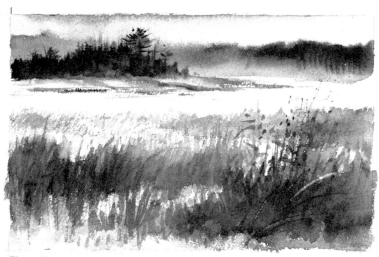

Figure 1

Demonstration

Steps 1 and 2. To paint the same subject again in a different season is a rewarding experience. In fall the overall tonality of the marshland is rich with a heavily textured blur of weeds and pods in warm colors. The rough, Figure 1, offers the best opportunity to emphasize the textures at close range. There is no need to pencil in this composition on the watercolor paper; better to do a broad wash study in order to decide on a flow-through pattern of light within the confusion of the field.

Additional washes of the same warm colors were brushed broadly over the field, going deeper in value but leaving patches where the original washes can peek through. In doing these second washes, I begin to concentrate on receding scale by diminishing the size of the brush strokes and alternating light against dark. Where the field meets the water, I let the strokes drag over the paper texture. Notice that I am still avoiding detail within the field and keeping the white paper intact.

After broadly indicating the basic composition with my No. 10 round and pale raw sienna, I sponge-dampened the upper half and painted in the sky and background hills with pale burnt sienna, cobalt blue, and touches of ultramarine blue. Since I like the look of wet mingled washes in sky and background, I try to paint it in values that will be strong enough to carry when the work is completed. Next, I washed various light colors over the field (raw sienna, burnt sienna, brown madder alizarin, and olive greens), preserving a ragged pattern of white paper.

The stand of trees was indicated with a few strokes of warm colors. The marsh under it is mostly raw sienna.

Step 3. The field pattern is developed once again with broad strokes, especially in the foreground, combining both olive greens and burnt sienna in wet washes that blur together. Notice that the shape of the white-paper passage has been altered by additional brush strokes of warm and cool colors. It is now a less obvious pattern. The

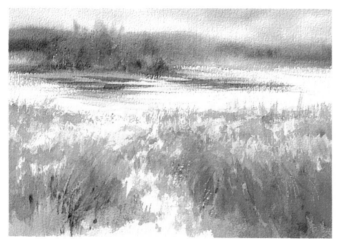

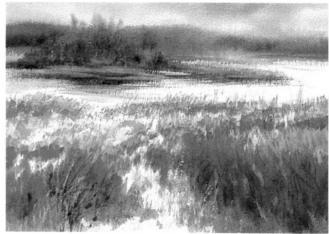

Step 1 and Step 2

Step 3

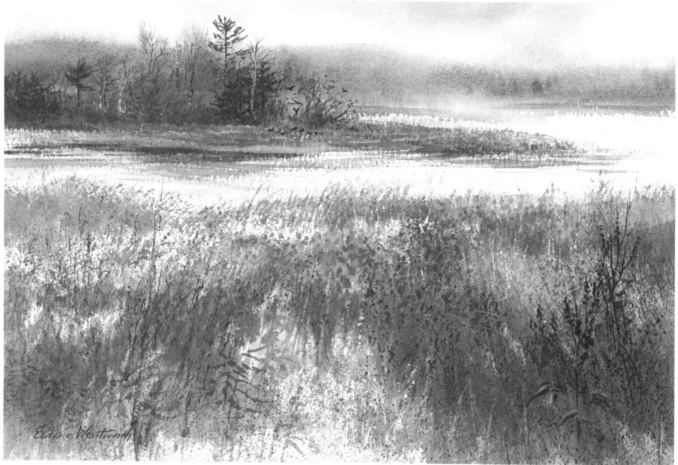

Step 4 *Finished painting*

distant background hills blur into the water area; there is no definition of where the shoreline is. One narrow stroke of raw sienna indicates this slightly, and as a result of this stroke, the original wash below it now reads as reflection in the water.

Step 4. The stand of trees could have been completed with the darks dominant or as accents. I decided on the latter. The base of this area was darkened with warm tones to anchor it to the ground. The grass at the base was deepened with raw sienna and touches of cadmium orange.

The reflections were darkened and added to, using cobalt blue with a dab of raw sienna. This repeats the blue of the background hills. On the right the added water ripples diffuse the definition of the jutting landforms.

Most of this step was devoted to the field on this side of the river. All those rustling weeds are what attracted me in the first place, but if too many are detailed, the picture will become busy. A few well-defined weeds within the textured blur are more pleasant to focus on. At the river's edge cadmium orange and some pale greens were added in small dabs of paint. Moving to the left, I defined the stems of a few seaside goldenrod with olive green mixed from Winsor blue with raw sienna and a dab of burnt umber. I used a small pointed brush to add some burnt umber spatters.

On the right I enriched the color with the same olive greens. Some of the stems, leaves, and pods were defined with either olive green or burnt umber. It was spattered with a half-inch chisel, which produces a texture different in its characteristics from that done with the small round. These dark textures indicate the weed called stock. Meanwhile, the white-paper passages become increasingly more obscure, finally spattered with cadmium orange and light greens.

My decision was to leave the far background as is. You can visualize for yourself how it would look a value darker.

Barn Window
22 × 30 inches, medium surface board

Barn Window / *Elaine Wentworth*

During her teenage summers, our daughter, Janet, had a way of making friends with the Down East "old-timers." One day we found her deeply engrossed in painting inside Mr. Watts's barn. Only a small floor space was cleared, the rest cluttered with a rich accumulation of antique farm equipment, carpentry tools, lanterns, baskets, and bottles, all diffused with dust and filtered sunlight from the murky windows. Her solitude ended; the remaining space was soon crammed with the easels of her parents. Windows highlight the details of an interior enabling us to see the ordinary in a special way, while at the same time framing in for us a view of the outside world.

My favorite spot was the window next to the blue hanging cupboard. The old railroad lantern and hammer, painted with raw sienna, burnt sienna, and ultramarine blue, are silhouetted against the light shape. The windowpane mullions are narrow and "chewed up," and that's the way they should be emphasized, using lost and found edges and several values. The diffused background helps break up the geometric pattern of the panes. The glass has pale washes of yellow and blue gray, textured here and there with palm prints and flicks of paint.

Time Worn
21×29 inches, 300-lb. medium surface paper, Fabriano

All other farm machinery's gone in,
And some of it on no more legs and wheel
Than the grindstone can boast to stand or go.
—Robert Frost, "The Grindstone"

Time Worn / *Elaine Wentworth*

Early fall, a few years ago, our friend Syd Davis took Murray and me to Mosquito Island in his lobster boat every day for a week. Between us we have an extensive collection of island sketches and paintings. This old grinding wheel was behind the empty fieldstone house with its boarded-up windows. The wheel was a soft greenish-gray, dented and textured with age. Placed just off center, it dominates the composition; however, the opening in the row of trees leads one to a restful distance. Although there is rich color in the golden field and dark woods, it remains subordinate to the low-key atmosphere that enhances the mood of lonely abandonment.

I finished the painting back at our camp on the mainland. Shadows across the wheel were added, not to indicate sunlight, but to counteract the sensation that the wheel was spinning as you viewed it. Layers of transparent washes were built up slowly. A wash of cobalt blue was added to the back field in the final stage. The foreground is spattered with several colors—raw sienna, manganese and Winsor blue, burnt sienna—to indicate lichen and texture on the flat ledge. The background spruces and pines have warm color mingled into the blue-green washes, brown madder alizarin and raw sienna. White paper highlights were left on the top of the wheel, on its wood frame, and also on the ledge.

171

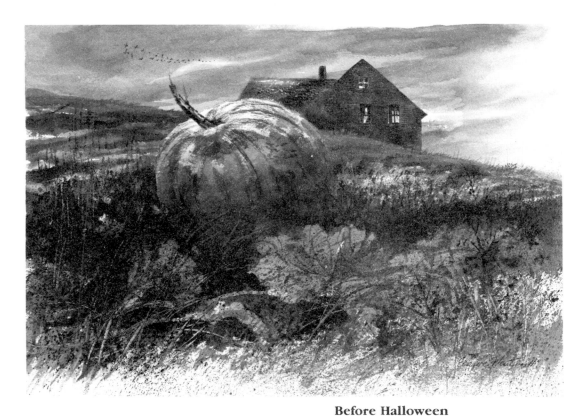

Before Halloween
10 × 14 inches, 140-lb. d'Arches medium surface

Before Halloween / *Elaine Wentworth*

Fall has two distinct moods. In spite of the lively color and motion swirling about, there is the rustle of decay underfoot. There is that element of sadness to the end of flowering and harvesting and the coming once again of the frozen earth. A vague spookiness prevails in the land . . . some of the pumpkins still in the field will turn into jack-o'-lanterns, and some of the dried cornstalks will decorate the lantern posts for Halloween. Before Halloween, the high intensity of autumn gives way as the spookiness builds momentum.

At the far end of the field the empty barn with its broken windowpanes gives this feeling a sharp focus. Crouching in the pumpkin patch, I see the round orange form as dominant, the barn an assemblage of geometric shapes silhouetted behind it. How to capture the mood without cramming the composition is the problem. Perhaps the cloudy skies behind the barn with accents of light showing through the windows is enough, but the great pumpkin seems an integral part of the scene.

If a subject holds enough interest for you, don't settle for one version; try several—do a series of studies.

One of my early studies of the scene

172

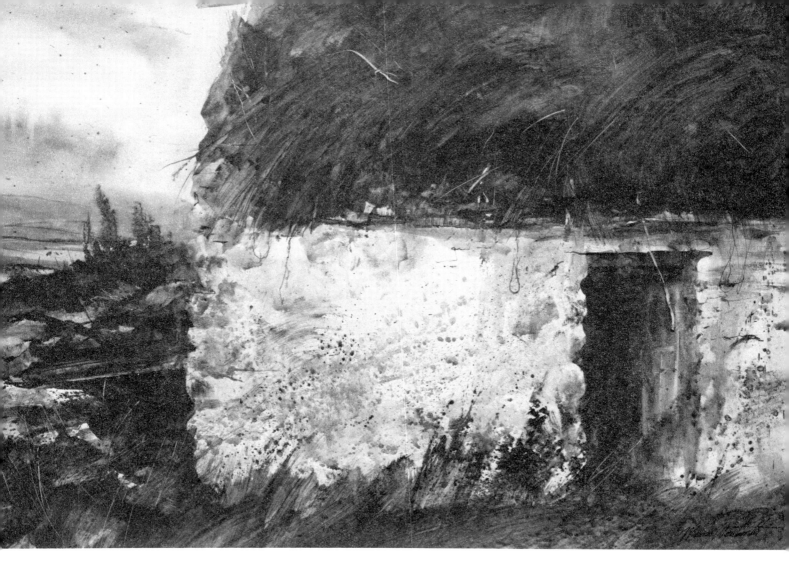

Limestone (County Kerry, Ireland)
20 × 30 inches, smooth paper

Limestone (County Kerry, Ireland) / *Murray Wentworth*

A trip to Ireland several years ago gave me lasting impressions that can still be used today. The exciting variations in tonal ranges and contrasts were almost overpowering. Many roughs were made on location. I couldn't resist working large, at least 20 × 30 inches in size. Most are considered roughs, but some worked well enough to pull into finished paintings.

The work done on location, combined with photos and sketches, gave me enough to work from later without losing the immediate feelings that were present when painting on the spot.

This painting of a section of farm building was carefully planned and drawn on location and brought back to the same spot

the next day for painting. The weather was rainy and unpredictable, and I had to wait for a clear spell before I could start working in paint. Once started the painting was carried to near completion on location. Final textures and some refinement were done back home. The white limestone is the visual excitement that stimulated my interest in the scene. Stone textures are a big challenge!

The major problem when traveling to a new place is that you see too much, and it takes discipline to narrow down your vision to the important things. To me this piece says what I wanted to convey about Ireland without trying to do the entire countryside.

Index